Creative Digital Photography

Creative Digital Photography

52 MORE WEEKEND PROJECTS → → → → CHRIS GATCUM

ILEX

First published in the UK in 2012 by:

I L E X
210 High Street
Lewes
East Sussex
BN7 2NS
www.ilex-press.com

Distributed worldwide (except North America)
by Thames & Hudson Ltd., 181A High Holborn,
London WC1V 7QX, United Kingdom

Publisher: Alastair Campbell
Associate Publisher: Adam Juniper
Managing Editor: Natalia Price-Cabrera
Editor: Tara Gallagher
Specialist Editor: Frank Gallaugher
Creative Director: James Hollywell
Senior Designer: Ginny Zeal
Designer: Simon Goggin
Colour Origination: Ivy Press Reprographics

British Library Cataloguing-in-Publication Data
A catalogue record for this book is available from
the British Library.

ISBN 978-1-908150-99-8

Printed and bound in China

CONTENTS

INTRODUCTION

It doesn't matter if you're fascinated by the "hard core" science of traditional chemical mixing and film developing or prefer pixel-pushing in the high-tech world of digital imaging. Nor does it matter if you use a point-and-shoot camera or the latest system camera to get your photographic gratification. The bottom line is that photography is a multifaceted thing with something for everyone, regardless of experience, interests, or whatever else you care to mention.

Yet despite its pluralism, it's surprisingly easy to find yourself ploughing the same furrow time and time again, intentionally or subconsciously turning your camera on the same subjects; using the same techniques; and ultimately ending up with very similar results. There's nothing wrong with this at all—repeatedly visiting the same locations or photographing the same faces is a great way of developing your skills, regardless of whether you actively set out to do this or not—but stepping outside your comfort zone and trying something new can have a profound effect on your image-making. It could be that shooting a different subject to normal leads you to a whole new set of options—shooting portraits in the street if you're usually a landscape snapper will introduce new skills, for example—or that a new piece of equipment revolutionizes your shots.

That, fundamentally, is what this book is about: trying something new to help expand your creative repertoire. Whether you experiment with stereo images with your digital camera, or load up a long-forgotten 35mm camera with redscale film, there's a whole chapter of in-camera projects to get you started, and plenty more projects if you like to work harder post-capture with your image-editing software. Between these are chapters dedicated to equipment, with plenty of accessories that you can make to try out a new technique or simply save yourself some money.

I'm not saying for a moment that these projects will immediately make you more creative—that's down to you, I'm afraid—but each one has the potential to help you in your quest to produce exciting images, and will hopefully inspire you to pick up your camera, try something new, and above all, have fun!

SHOOTING

It doesn't matter if you're shooting on film or recording images digitally; using a high-end digital SLR or a humble point-and-shoot compact camera; or coming to photography with little or no experience, or years of practice—it's the end result that really matters. This chapter has something for everyone. Analog and digital projects nestle side by side with one common goal in mind—to help you take some great shots.

01 EXPOSE TO THE RIGHT

The sensor in a digital camera is comprised of millions of photosites, each of which is capable of measuring very precisely the amount of light that falls onto it. Counter-intuitively a photosite generates an analog signal when exposed to light: the more light the photosite is exposed to, the greater the strength of the signal. It's only after the image has been captured that the analog signal is converted into a string of numbers to be recorded as a digital file. In a 12-bit Raw file, 4098 discrete tonal values are extracted from the original analog signal. These tonal values range from black (no signal) through to white (maximum signal).

A typical digital SLR has a dynamic range of approximately 10 stops. However, 2048 (half) of the 4098 tonal values are allocated to the brightest stop; half of the remaining tonal values (1024) are used in the next brightest stop; half again (512) in the next brightest stop; and so on, until there are just 32 tonal values allocated to the darkest part of an image. This means that there is far more usable image data in the highlights of an image than in the shadows.

Exposing to the right (or ETTR) maximizes the amount of usable data in an image, creating more latitude for adjustments in post-production and reducing the potential problem of noise in the shadow areas. This is achieved by deliberately placing the exposure so that your image is as light as possible, without the highlights being lost. As a result, the histogram of an ETTR image is skewed to the right, hence the name of the technique.

Shooting an ETTR image is easier if your camera has Live View and is able to display a live histogram: You can adjust the exposure until the histogram is moved as far right as possible without clipping and then take the shot. If you're using manual exposure, adjust either the shutter speed or aperture depending on which is most important to the shot. In other shooting modes use exposure compensation to adjust the exposure. If your camera doesn't have Live View, shoot a test image and view the histogram, adjusting the exposure and reshooting if necessary.

Once your bright Raw file has been imported into your Raw conversion software you need to "normalize" the image using exposure, levels, or curves tools to "correct" the exposure. This will result in the image density and color being restored, with maximum image data and minimal noise.

WHAT YOU NEED
- Digital camera with histogram and Raw
- Raw conversion software

DIFFICULTY ✶ ✶

NOTES

ETTR is only applicable when recording Raw files.

Set the picture style on your camera to "neutral" (or similar) to make the histogram as accurate as possible.

Most Raw conversion software has an auto-exposure function, which often works well. However, you may find that further tweaks are necessary—ultimately, it's you who knows how the image should look, not the software.

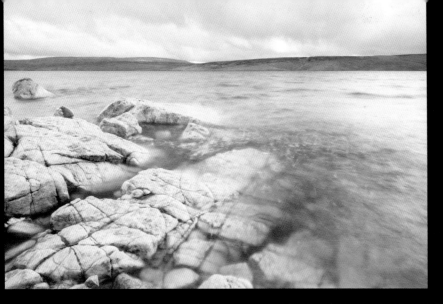

Your image will be light and lacking in contrast when you expose to the right (left and above), but when you adjust the histogram (below), the density and color will return with maximum image data.

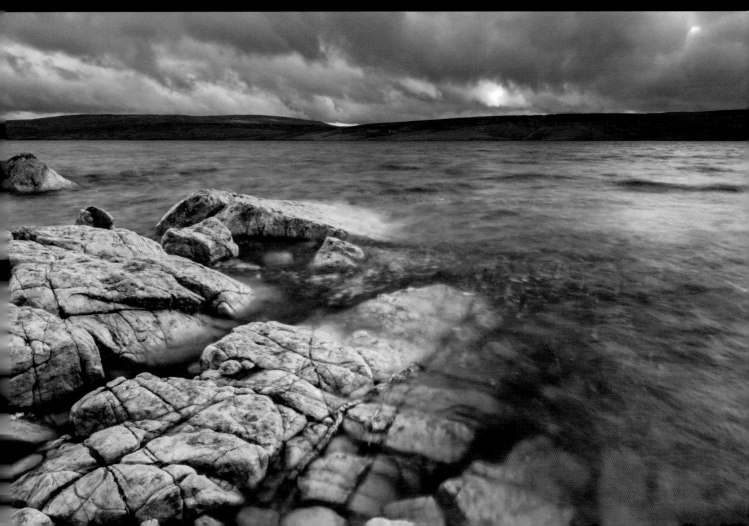

Silhouettes were a popular form of image-making, long before photography had been conceived. However, they have always received something of a mixed reception in photography: a silhouette that's done badly can end up as an unreadable mess of black, while attempting to photograph a subject against a bright background can easily lead to accidental silhouettes as your camera attempts to produce the "best" exposure.

Yet while the humble silhouette is maligned by some photographers, there's no doubt that the stark black outlines also have a graphic power where shape becomes more important than detail, and a story can be told using broader strokes. So, why not set your preconceptions aside and think about adding stunning silhouettes to your creative repertoire?

SUBJECTS

The easiest way to create a poor silhouette is to pick an inappropriate subject: Something that appears to have great potential when you look at it may not be quite so hot when you photograph it. As a general rule, the simpler the shapes, the fewer there are, and the less they overlap, the stronger the result will be. For example, if you're photographing a couple of figures in silhouette, make sure there is space around each of them so they can both be seen in their entirety. You may know it's two people when you photograph them, but if they overlap it's easy for them to be transformed into a two-headed, four-armed "freak" when they're seen in silhouette (although that could work!).

This isn't helped by the fact that objects seen in silhouette tend to lose a certain amount of depth. This means that you also need to be aware of what is behind and in front of your subject, as something in the foreground will not necessarily be read as being "closer" when it's photographed—it could instead just appear oversized.

WHAT YOU NEED
• All you need is a camera!

DIFFICULTY ★

TIPS

Although your choice of subject is important, you should also pay attention to the background in your shot. Positioning your subject against a relatively plain background will enhance the graphic nature of your silhouettes. A classic background is a fiery sky at sunset, although you may find that you need to shoot from a low viewpoint to make best use of the strong color that occur.

If your potential subject is close to the camera, make sure the built-in flash is switched off before attempting to shoot a silhouette: if the flash fires, you won't get a silhouette.

Consider setting the "wrong" white balance deliberately: Using a tungsten white balance setting in daylight will give your silhouette shot a strong blue color cast, similar to using a blue filter on the lens or toning a monochrome picture.

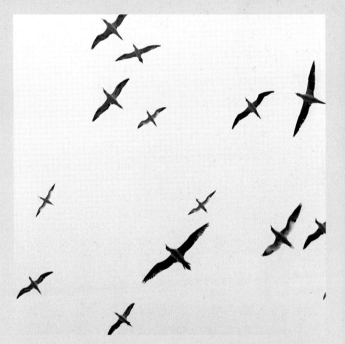

Above: If you aim your camera at a featureless sky, it's almost guaranteed to underexpose the shot. Here it transforms the birds into dark silhouettes.

Right: I treated this silhouette to a redscale look during post-production: Project 49 explains how it was done.

EXPOSURE

The most striking silhouettes utilize strong backlighting and a carefully placed exposure so the subject is rendered without detail. However, some cameras actively attempt to identify and overcome strong backlighting when you use their general metering mode (matrix metering, evaluative metering, or similar), either by adjusting the exposure to compensate, or by employing some form of dynamic range optimization. This doesn't mean that your camera's meter is useless for shooting silhouettes—you simply need to know what it will do.

If you find it consistently tries to compensate for heavy backlighting, then one option is to dial in negative (-) exposure compensation. This will effectively underexpose the shot, reducing the brightness of your subject and helping to transform it into a strong, featureless "shadow."

Alternatively, you can use your camera's spot meter. Take an exposure reading from an area you want to appear as a midtone (usually a bright area in the background) and either lock the exposure with your camera's Automatic Exposure Lock (AEL) feature, or set the shooting mode to Manual (M) and dial in the aperture and shutter speed yourself. In both instances you will have an exposure that is set for the (bright) background, with the unlit subject falling into shadow.

POST-PROCESSING

Providing you get your exposure right in-camera, there's often minimal need for any post-capture image editing. However, that's not to say that your silhouettes won't benefit from a touch of post-production work. For a start, you may want to make sure that your subject is a pure black silhouette by "burning in" the dark tones using your editing program's "Burn" tool (or similar).

The background may also benefit from being darkened slightly, which will help intensify the color. This is especially effective with sunset silhouettes, where an overall reduction in brightness (using Levels, for example) can really make the colors "pop." This can be taken further by combining it with a slight increase in color saturation or vibrance as well—most editing programs have at least one tool that can be used to intensify the colors in an image.

Alternatively, you may find that you want to remove the color altogether to create a black-and-white image. With certain shots this can be incredibly effective, and imbue your image with a mysterious, "film noir" look. Toning your silhouettes can also work well, be it a fairly traditional sepia tone, a more extreme redscale look (see Project 04 and Project 49), or something else altogether.

02 > > >

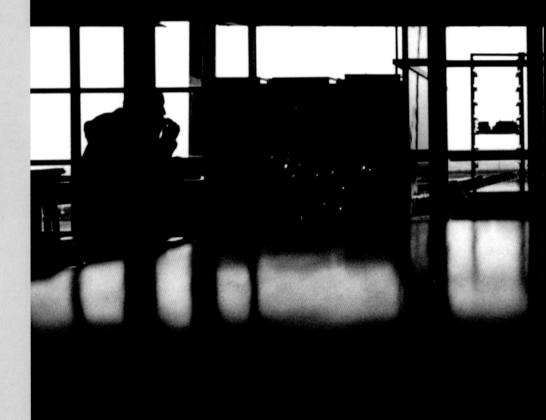

Stunning silhouettes can be
found in the most innocuous of
places: this image was taken in
a restaurant, but the "film noir"
style makes it look like a still from
a movie.

08 SPROCKET SHOTS

Few things say "shot on film" quite as clearly as the sprocket holes of a 35mm film frame. Indeed, 35mm sprocket holes are so intrinsically linked with analog photography that companies such as Lomography and SuperHeadz now produce cameras designed specifically to shoot across the full width of your 35mm film (the Sprocket Rocket and Blackbird, Fly respectively), while adapters will allow you to load 35mm film into your medium-format Holga or Diana "toy" camera to achieve a similar end result.

However, you don't need to spend a lot of money on a camera or an adapter if you want to shoot 35mm "sprocket shots." The fact is, almost any medium-format camera can be loaded with 35mm film, without any fancy adapter, and that includes a whole host of vintage kit that you'll find in yardsales or selling on eBay at stupid-low prices. For this project I'm going to be using an Ilford Super Sporti from the early 1960s. This rudimentary, 6 x 6cm square-shooter is a bit rough around the edges, but is fully functional and cost me just $7.50 (£5) including shipping. Anything similar will work just as well, so keep an eye out for those vintage bargains.

Holgas are a popular choice of camera for sprocket shots, with the 35mm frames displaying all of the plastic lens' lo-fi characteristics.

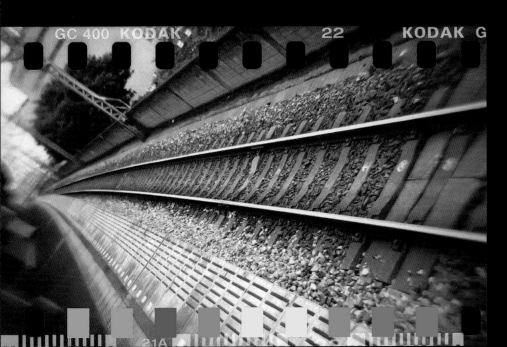

LOADING

Although medium-format cameras come in an array of shapes and sizes, the same basic loading principles apply to most. You might have to adjust the process slightly if you're using a particularly unusual camera design, but it's not exactly rocket science—your 35mm film cassette needs to sit snugly in the place usually reserved for an unexposed 120 format roll of film, and will wind on to an empty medium-format take-up spool.

The easiest way of making sure that your 35mm film is held securely is to pack the space above and below it in the camera with foam or sponge (1). Two squares of foam measuring around 2 x 2 inches (5 x 5cm) should do the job, but the key thing is that you compress them to get them into the camera—their natural expansion will help to "hold" your 35mm cassette in place. You may find that a thin strip of sponge sitting between the camera back and the film cassette can also help to prevent the film from rattling around inside the camera, although the Ilford Super Sporti I'm using has a rotating metal "door" and a film tensioner that does this job automatically.

The next step is to modify the camera's take-up spool (2). Although you're shooting 35mm film, you'll be winding it onto a standard 120 format spool, just as you would if you were using medium-format film. To encourage the smaller format film to stay straight as it passes through the camera you need to narrow the take-up spool using rubber bands (elasticated hair bands are ideal). Wrap several bands around the top and bottom of the spool, leaving a gap in the middle that is roughly the same height as your 35mm film.

Finally, take the leader of your 35mm film and use low-tack masking tape to attach it to the take-up spool. Wind the film on a few turns with the camera back open to be sure it's being taken up properly (3), then close the back. However, before you start shooting there's one more vital step: tape up the red frame counter window on the back of the camera! Although this lets you see the frame numbers on a medium-format film, 35mm film doesn't have any backing paper, which means this window is guaranteed to fog your film. Electrical tape or a thick piece of card over the window will stop this from happening.

You can load most medium-format cameras with 35mm film, but a "35mm style" viewfinder camera such as this Ilford Super Sporti is ideal (above right). Use sponge or foam to hold the 35mm film cassette in place and elasticated hair bands to modify the take-up spool.

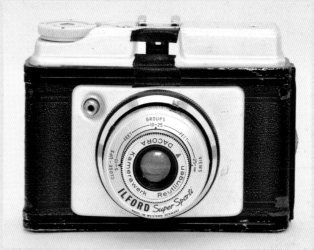

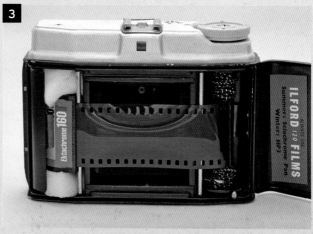

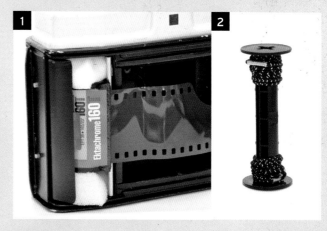

SHOOTING

You can shoot your 35mm film as usual in terms of focusing and setting the exposure, but there's a significant difference when it comes to winding on to the next frame. As mentioned, with medium-format film you would use the numbers on the backing paper to align the next shot, but this just won't work with 35mm film. Instead, you need to work out precisely how far you need to turn your camera's winding wheel/crank/knob to advance your 35mm film by one frame. The easiest way to do this is to use a scrap roll of 35mm film as outlined below.

UNLOADING

This is where a dedicated sprocket-shooting camera or a commercial adapter has a distinct advantage over the DIY approach, as you'll most likely be able to rewind your film in-camera once you get to the end of the roll. Conversely, a zero-cost 35mm conversion won't have a rewind facility, so you will need to head into a darkroom to unload your camera (or at the very least unload your film in a film changing bag) and then manually rewind the film back into its cassette. Obviously, this can have an impact when you're out in the field: when you finish a roll it's not as straightforward as rewinding your film, unloading it, and dropping in a fresh film.

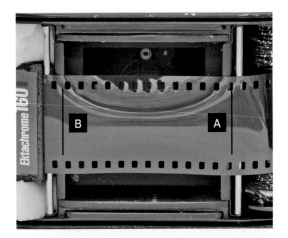

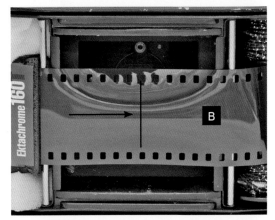

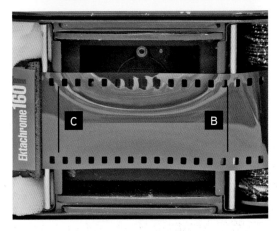

Winding on
To determine how far you have to wind your 35mm film on, load a scrap roll and mark the edges of the frame (A and B). Wind the film on until the mark at the left (B) is aligned with the right edge of the frame, making a note of how far you have to turn the winding wheel. Mark the new left edge of the film (C) and repeat the process to accurately discover how far you have to wind on between shots. With my Ilford Super Sporti I have to turn the winding wheel approximately 1½ turns.

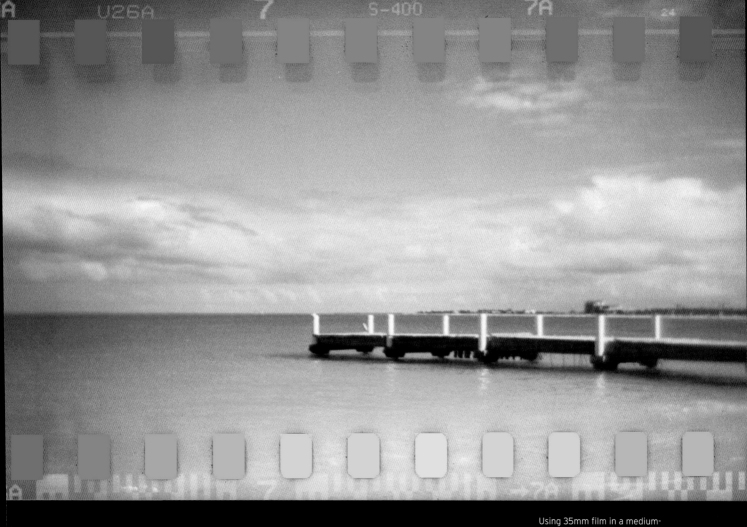

Using 35mm film in a medium-
format camera produces naturally

04 REDSCALE

No one knows for sure who first discovered "redscale" photography, but it's a fairly safe bet that it came about by accident, most likely when someone loaded large-format sheet film into a darkslide the wrong way round. The result would have been that the film was exposed through the back of the emulsion, so the light hit the film's red-sensitive layer first. Because of this, redscale images suffer from often-extreme color shifts, from intense red/orange hues through to a more subtle magenta/blue color cast.

This technique has since been jumped on by analog photographers, especially lo-fi enthusiasts shooting with toy cameras. Indeed, the technique has become so popular that Lomography has launched its own Redscale film (in both 35mm and 120 formats), while Rollei offers a choice of two 35mm redscale emulsions (Redbird and Nightbird). Each of these films works in exactly the same way as a regular color print film; you load it as normal, expose it as per the given ISO rating, and process it through the standard C-41 negative process. The only difference is that the film faces in the opposite direction in your camera, so the emulsion side is *away* from the lens, creating the intentionally "red" image.

Shooting ready-rolled redscale is by far the easiest option, especially if you're using a medium-format camera, but it isn't the only one: you can also roll your own redscale film. The downside to doing this is that you need to prepare the film to start with, which requires access to a darkroom (or a room that you can black out), as you will be unspooling entire rolls of film. A film changing bag will work at a push, but it's easy to crease or dent your film in the confines of a bag, leading to permanent marks on your images.

So why bother if it's so complex? Well, rolling your own film means you will be able to experiment with a much wider range of emulsions (any color film can potentially be used), each of which is capable of producing different results to the rest. It is also likely to be cheaper than a "ready made" solution, so you have the double benefits of greater creativity at a lower cost!

NOTES

While it is possible to re-roll 120 format film for redscale shooting, the film's backing paper makes this difficult. Large-format redscale is much easier: simply load your film back to front in the darkslide!

You can re-spool color negative and color transparency film. However, negative film has a much wider exposure latitude, so it's easier to get a usable image.

Redscale isn't just about highly saturated "red" images: the effect can be far more subtle.

ROLLING 35MM REDSCALE

1 **IN THE LIGHT**, cut off the leader of your film.

2 **IN TOTAL DARKNESS** (ideally in a darkroom), pull all of the film out of your 35mm cassette. Do not pull it so hard that you rip it off the spool inside though! Cut the film, leaving at least 1 inch/2.5cm (ideally a little bit more) sticking out of the cassette.

3 Turn the loose film around so the emulsion is next to the base of the "stub" sticking out of the cassette and tape the two together.

4 Wind the film back into the cassette, leaving the last 2-3 inches/5.8cm hanging out to become the "leader."

5 **IN THE LIGHT**, cut the end of your redscale film to roughly the same shape as a standard film leader. Your film is now ready to be loaded into a camera as you would any regular 35mm film.

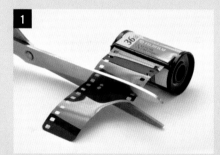

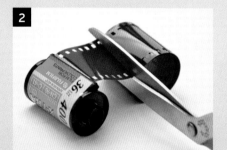

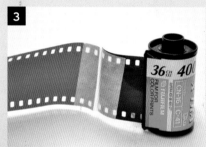

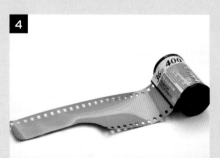

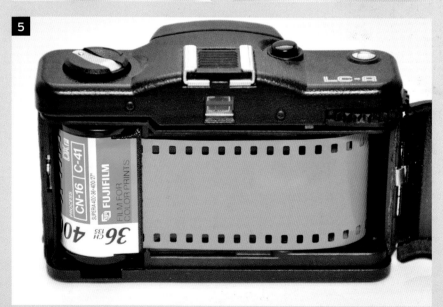

SHOOTING

With your redscale film loaded into your chosen camera you can shoot as normal. However, if you're using an emulsion for the first time it's a good idea to bracket your shots to find the optimum settings for your chosen emulsion—some respond better to underexposure, others to overexposure. Keep notes of the exposure differences so that once the roll's processed you can see how changing the exposure affects the color (or not, as the case may be).

If you're using a camera with automatic exposure metering, this test roll will enable you to give your homemade redscale emulsion a specific ISO rating. If a film works consistently better when overexposed by 1 stop, for example, then you can decrease its ISO by one stop. Conversely, if it gives better results if it's underexposed, then increase the ISO by the same amount. The next time you use the same emulsion for redscale shooting, set the revised ISO and your in-camera meter will automatically be set to give you the "best" results.

PROCESSING

As the film you're using is standard color negative (or possibly color transparency) film, it goes through the exact same process as a "standard" film of its type, so a C-41 process for negative film, and an E-6 process for transparency film. You will need to tell the lab what you've done though, so that they don't try to color-correct your prints. Making them aware that your film is taped to the spool is also helpful, as the last thing you want is to collect it, only to find that some rogue sticky tape has worked its way into their processing machine and brought the whole thing to a halt.

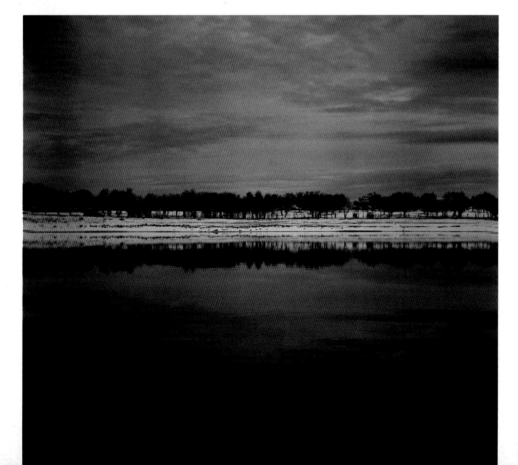

> **NOTE**
>
> It can be slightly trickier to load a homemade redscale film because you have "flipped" the natural curl of the film. Instead of it curling onto your camera's take-up spool it will curl away from it, so be careful not to crease the film as you bend it in the opposite direction.

Right: Strong, graphic shapes (and silhouettes) make good redscale subjects, as the process reduces scenes to shape and tone, similar to black-and-white photography.

Left: It's possible to make your own medium-format redscale film, but it is much harder than it is with 35mm film, making Lomography's 120 Redscale film a popular choice.

Infrared (IR) light is invisible to the human eye as it is beyond the visible color in the spectrum. However, it is not beyond the recording range of a digital camera. This means that a camera can be modified (or a filter can be used) to capture infrared images, transforming a regular scene into something totally unexpected, sometimes even magical.

MODIFIED CAMERAS

The majority of digital cameras use some form of infrared-blocking filter. This filter is used to prevent infrared light causing unwanted color shifts in regular photographs, which is great for standard shots, but it means that most of the infrared light that the camera could potentially record is blocked. One solution is to remove the infrared-blocking filter in front of the sensor and replace it with a clear filter. The process of removing the IR-blocking filter can be done by several companies and is the preferred option for infrared photographers. However, while removing the IR-blocking filter will enable your camera to record infrared, it will no longer be suitable for regular photography—it will *only* be capable of shooting infrared. For this reason, many IR photographers will invest in a second camera body, specifically for IR conversion.

UNMODIFIED CAMERAS

Although most cameras have an infrared-blocking filter in front of the sensor, these filters are not perfect and they don't prevent all of the infrared light from reaching the sensor. This means that a specialized infrared filter can be used on the lens that will allow only infrared light to pass through. The results are similar to those you would get with a modified camera, but you don't lose the ability to shoot regular photos—you can simply remove the filter as you would a polarizer or any other filter.

Of course, there is a disadvantage, otherwise everyone would choose this option rather than permanently modifying their camera. The problem is, using a filter will extend your shutter speeds considerably, which doesn't happen with a modified camera. Depending on how strong your filter is, exposures of several seconds—sometimes even minutes—may be required to record an IR image, so there is little chance of shooting handheld. There is also a very high chance of motion blur caused by the slow shutter speed.

<div>
WHAT YOU NEED

Modified digital SLR or digital camera with infrared filter

</div>

DIFFICULTY ★ ★

NOTE

Not all digital SLR lenses are suitable for IR photography. Due to their optical design, some lenses will produce a "hotspot," which is a very distracting patch of light in the center of the lens. For example, the Canon 50mm $f/1.8$ lens is fine for IR work, but the Canon 50mm $f/1.4$ is not.

TIP

Point-and-shoot cameras often have weaker IR-blocking filters than digital SLRs, so allow more infrared light through to the sensor. Cheap brands usually allow even more IR light through, enabling you to add an infrared filter and shoot with shorter exposure times.

Using a filter over the lens is the cheapest and easiest way to experience IR image-making.

INFRARED FILTERS

Assuming you don't want to modify your camera, you will need to get an infrared filter. There are several types available, which filter different levels of visible light: the cut-off point of the filter is measured in nanometers (nm). Visible red wavelengths of light occupy the range 620nm–750nm in the spectrum, which means that any filter with a cut-off point below 750nm will also allow some visible light to pass through. Filters with a cut off above 750nm will only capture infrared light. This is an important difference: If the filter allows both visible and infrared light then your final result will be a "false-color" photograph, while if the filter only allows infrared light to pass through, the result is a black-and-white photograph. One of the most popular filters is Hoya's R72 (720nm) filter, which allows some visible light through.

Taking a photograph with an infrared filter is similar to taking a regular shot, but there are some twists. For a start, you will not be able to see the scene through the viewfinder or Live View due to the filter's opacity, so you need to frame your shot and adjust the focus before attaching the filter. There is also a small focus shift between visible and infrared light, which needs to be compensated for. As most modern lenses no longer have an IR focus mark, the easiest way of doing this is to use a generous depth of field, so set apertures such as ƒ/8 or ƒ/11 for landscapes to make sure your focus will be fine.

With regards to the exposure time, this will need to be calculated by trial and error, so it's very important to check the RGB histogram after the shot: the red channel should appear overexposed and the green and blue channels underexposed. This is because your filter is letting some visible red light through, meaning your red channel is exposed more quickly during a long exposure than the green and blue channels that are capturing infrared light. If your red channel is clipped entirely then you will get a pure infrared photograph with no visible light. The aim is to expose as much as possible for the blue and green channel, while leaving some light in the red. The result will look very blue, but that's OK—you'll fix that at the post-processing stage. In fact, white balance is really difficult to handle in infrared photography, so rather than try to correct your images in-camera, shoot Raw images that can be adjusted more easily.

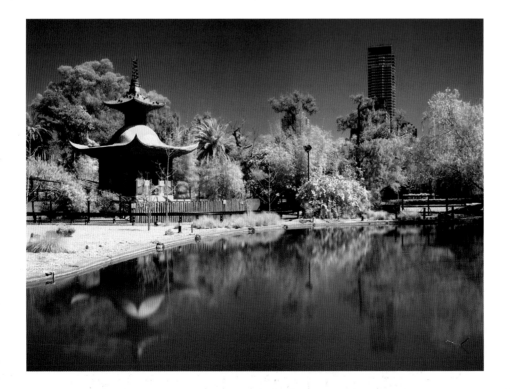

TIPS

The following is a simple step-by-step "recipe" for shooting IR images with a filter:

1. Mount your camera on a tripod
2. Set the camera to Manual (M) mode
3. Shoot Raw files
4. Use an aperture of ƒ/5.6-ƒ/11
5. Set the ISO to ISO 400 or 800
6. Focus and frame your shot without the filter
7. Attach the IR filter
8. Set the exposure time to 10 seconds as a start point
9. Take your shot, check the histogram, and adjust the exposure time accordingly

PROCESSING

The first step with your IR pictures is to adjust the white balance. Ultimately, this is an artistic decision due to the "false color" in the image, but a common procedure is to use grass or foliage as a neutral color and adjust from there. If you want to be more precise you can take a shot of a gray card through your IR filter and use that as a reference.

Once the white balance is adjusted, the next step is to decide if you want your photograph to appear with blue hues or red hues. To change from one style to the other you have to swap the red and blue channels: there are actions for

Photoshop and other editing programs that will do this for you. Again, this is an artistic decision, but if you were wondering why your shots were blue and many others were red, you just found the answer!

Infrared photos are usually very low in contrast, so this also needs to be corrected (Auto-levels is usually sufficient), and you will probably want to deal with noise too. All infrared shots are noisy (because the green and blue channels are usually underexposed), so running good noise-reduction software is therefore an important part of the processing.

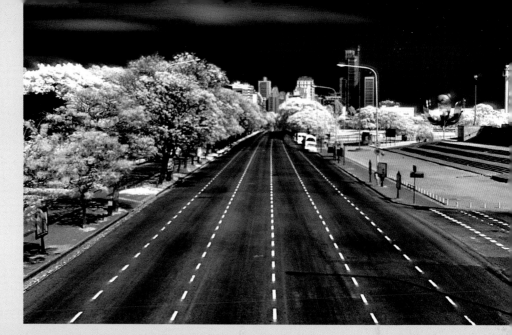

06 LEVITATION

Levitation shots present the viewer with something unexpected, which instantly makes them appealing, but they need to be done well if you want the viewer to suspend their disbelief and accept the subject floating in the picture before them. The best levitation photos are those that are truly believable, and in order to make them believable you have to take everything into account when you make your exposure(s): If there is movement, which way is the hair/clothing going to be moving? What is the lighting going to be like? Should there be a shadow beneath your subject? What shape is the shadow going to be? And so on... If everything has been thought about, then you are more likely to get a good result!

WHAT YOU NEED
- Digital camera
- Image-editing program with Layer masks

DIFFICULTY ✶ ✶

NOTE

Although you can "cut and paste" a subject from any shot and place it into another, you will find that the best results are achieved when you place your model in the actual background that you are going to use in the final image. The lighting will be totally realistic and this not only saves you editing time, but also produces the most convincing results.

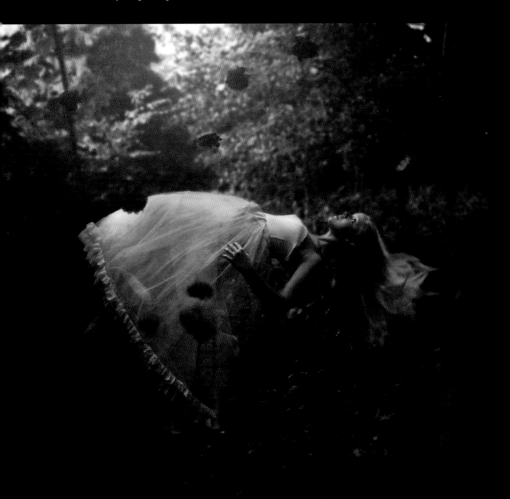

You don't need masses of gear to take successful levitation shots, but you do need a bit of skill if you want your levitations to be as convincing as this one (left).

SHOOTING

The basic process for a levitation picture is straightforward: take one photograph of the background, without the model in it, and another photograph with the model posed on a stool or platform. You then edit the two together in your image-editing program.

However, while this suggests that much of the work is done on the computer, the shooting stage is absolutely vital in getting the best material to work with. For a start, a tripod is essential if you want to create a believable levitation, as it will make sure that the camera doesn't move between shots. It's a good idea to work manually as much as possible, because if your focus and exposure don't change between shots, it will make your post-production work much easier.

Start by taking one shot of the scene without your model in it, making sure that the area you intend your subject to occupy is in focus. This will be your background shot. Then, bring in your subject and have them pose on a chair, stool, or other support, in a way that suggests they are floating. It doesn't matter if you can see the legs of the stool (these will be removed digitally), but it is very important to pay attention to the details noted above. You may even want to consider taking more than one shot of your subject. If you want to create the effect of someone falling, for example, you might want to take one shot of their hair moving, another of the dress movement, and a third exposure that records their pose, all the while making sure that they remain as still as possible. Either way, you should have at least two shots to combine: one containing just the background and the other containing the subject.

EDITING

The main editing tool used for levitation shots is Layer masks, which allow you to reveal and conceal parts of an image. Layer masks are a feature of numerous editing programs, but in this example I'm using Photoshop.

 The first step is to select the Lasso tool from the toolbar and draw round the person you want to "levitate." When you've made your selection press Ctrl+J (Cmd+J if you are a Mac user) to make the selection into a new Layer.

 Drag and drop this layer onto the background picture (the shot without the model or stool), making sure to match it up with the background in terms of its position. If you used a tripod your layers should line up perfectly, and if you hold down the Shift key while you drag the layer across it should snap to exactly the right point on the new background.

Add a Layer mask to this layer (Layer>Layer Mask>Reveal All) and you will see a small white box appear next to the layer thumbnail in the Layers palette.

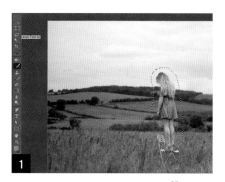

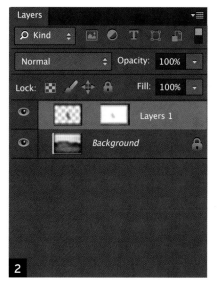

3 Select the Brush tool from the toolbar and set the foreground color to black. Making sure that you have selected the Layer mask (white box), you can paint over the parts of the layer that you don't want, allowing the layer underneath to show through. If you accidentally remove part of the layer, change the foreground color to white and paint the mask back in.

When you're masking areas such as legs and arms, it's a good idea to raise the "hardness" of your brush a little so the edges aren't as fuzzy (no one wants fuzzy legs!). After erasing the edges, assess your image. In some cases it will be good as it is, but in other images—including this one—it still looks as though the model is standing on something (even if it is invisible). To remedy this, I'll be taking the legs from another picture where they had been held up.

4 Using the same technique as Step 1, use the Lasso tool to cut out the leg from another picture and copy it across to the main image. Create a new layer mask for this layer and erase everything around the edge of the leg.

I repeated this process for the other leg and continued to make small adjustments to all of the layers. For this picture I wanted to make it look as though a butterfly was holding the subject up, so I also took a picture of a model butterfly close up and pasted that into my main image (below).

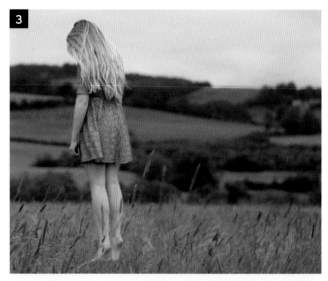

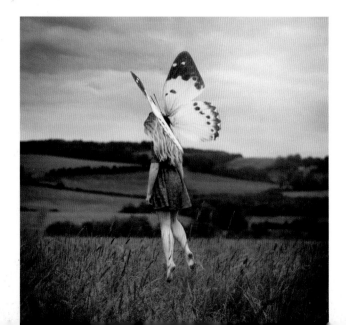

Right: A number of different exposures were needed to build this fantastical levitating scene, including individual shots of the "flying" books.

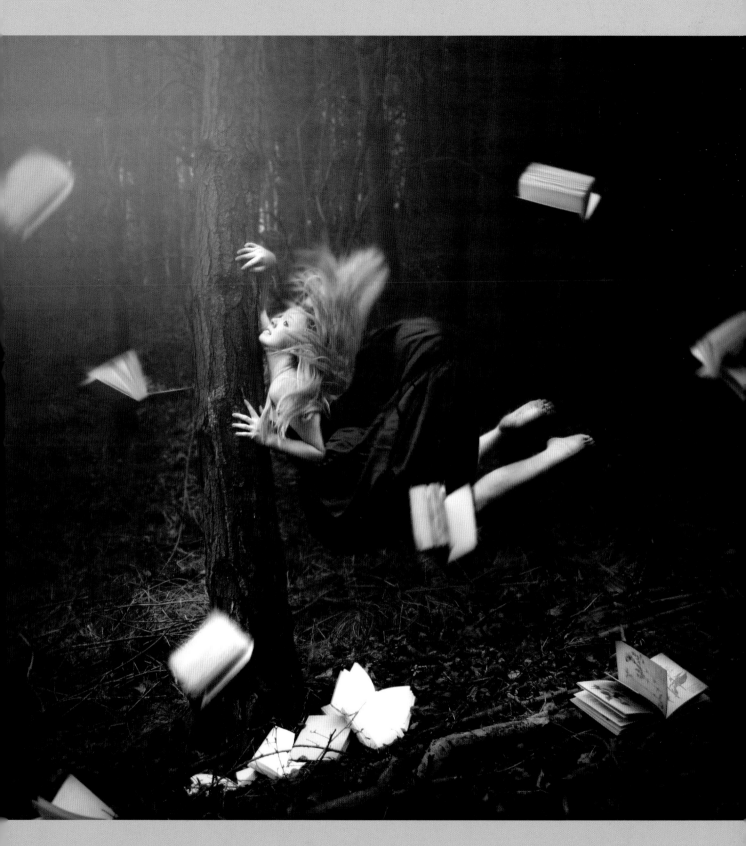

07 BRENIZER METHOD

Bigger isn't necessarily better, but there are certain benefits to using a digital camera with a large sensor. Aside from reduced noise levels, one of those benefits is that you can shoot images with a very shallow depth of field using a relatively wide-angle lens set to maximum aperture.

Professional fashion and wedding photographers commonly use full-frame, or even medium-format cameras so they can achieve this distinctive visual style, but it is much harder to recreate this look with a cropped-sensor camera. Often, the only way to achieve an appreciably shallow depth of field on a smaller format camera is to use a telephoto lens, but this limits your angle of view, making it difficult to frame a shot so that a generous amount of background is included.

So what do you do if you want a wide-angle view and a shallow depth of field? Well, according to the laws of physics this simply isn't possible—the two are mutually exclusive. However, thanks to the magic of image-editing software this is no longer strictly true, and there is a way to replicate this look with a standard digital SLR. The method described is largely credited to photographer Ryan Brenizer (www.ryanbrenizer. com), and for this reason is often referred to as the "Brenizer Method." The technique involves shooting multiple images and stitching them together using Adobe Photoshop's Photomerge function: a similar process to stitching together a panoramic photograph, but with a very different end result in mind.

A wide-angle view and ultra-shallow depth of field are not normally seen in the same shot, but the Brenizer method makes it possible.

SHOOTING

To achieve a shallow depth of field you will need to fit a reasonably long lens onto your camera: a focal length in the range of 85-105mm is a good starting point. If you're shooting with a compact camera use the longest end of the zoom range without using "digital" zoom. Set your camera to Manual to guarantee consistency across the range of images, and set the aperture to the maximum for the lens you're using. An aperture of f/2.8 is ideal, although it's also possible to get interesting results with an aperture of f/4 or f/5.6 with longer focal lengths. Set the shutter speed so you get an exposure that is correct for the scene you're shooting.

You can shoot either JPEG or Raw files, depending on your personal preference, and as always there are advantages and disadvantages to both. Shooting Raw files will certainly give you more control over the appearance of the final image sequence, but there will be a lot of images to process and they'll quickly fill a memory card. Conversely, if you shoot JPEGs it will be far less time-consuming, although the images may not be so easily optimized.

Composing your shot requires a certain amount of imagination, as you're going to shoot small sections of the scene to stitch together. As these individual segments will create the final image it's important to get it right, so try to visualize the edges of your final image and position yourself so that you can comfortably sweep your camera around to cover this entire area. Using a tripod is essential here.

Because the aim is to have just one distinct sliver of the scene looking sharp, you need to focus manually. Start by focusing on the main area you want sharp and then move the camera so that your first shot will be the top left corner of your scene. Take the shot and then pan right so that you overlap the first image slightly and shoot the next frame. Repeat this process until you reach the top right corner. Then, tilt the camera downward slightly and shoot again, this time panning from right to left until you reach the left edge of the image. Repeat this left-to-right, right-to-left shooting and panning until you've covered the entire area of your visualized final image. Then it's time to piece your photograph together.

Left: Piecing your photograph together will look something like this.

TIPS

If your subject is a person ask them to hold their position as best they can until you've stopped shooting.

Don't rush the shooting stage: the final image is only as good as all the individual images you've shot.

The more even the lighting of the scene, the easier it will be to set the correct exposure for the images—this method makes ND graduate filters challenging to use.

Shoot a greater area than the one you visualized for your final image: it is better to crop than to discover you haven't covered the entire scene.

IMAGE BLENDING

1 Start by copying your sequence of images into a single folder on your computer.

2 Launch Photoshop and go to File>Automate> Photomerge.

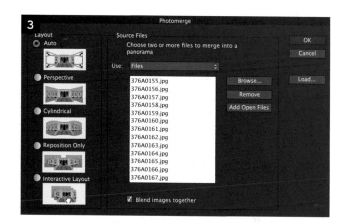

3 Click Browse and navigate to your folder of images. Select them all by clicking on a file and then pressing Ctrl+A (Windows) or Cmd+A (Mac). Press Open to return to the main Photomerge dialog and then OK to begin the merging process.

4 Your images will be merged and the results opened as a new image, with the individual images on separate layers. You can flatten the layers by selecting Layers> Flatten Image, or merge them to a single floating layer by choosing Layers>Merge Visible.

5 Your image will look ragged and uneven at this point, so use the Crop tool to crop the image. You can also rotate the image if you need to, or correct for perspective distortion by checking the Perspective button on the toolbar and dragging the corners of the Crop frame.

Left: The Brenizer method can create a heightened sense of three dimensions in an otherwise two-dimensional photograph.

08 FREELENSING

As the name suggests, freelensing involves "freeing" the lens from the camera body, resulting in photos that are characterized by a "vintage" feel that includes light leaks and a vignette. The depth of field is also shallow, no matter how far your subject is from your camera. However, the main reason to "freelens" is the control you have over the focus; you can move the focus point in all directions—forward or backward, up or down, and left or right—just by moving the detached lens. Because you are able to bring the focus point very close to the camera, freelensing is ideal for macro shots, but the tightened depth of field also allows you to apply a tilt/shift effect to your shots, where the scene seems miniaturized. The shallow depth of field can be utilized effectively in portraiture as well.

LENS CHOICE

The lens is what matters most in freelensing. You will need a lens with a minimum focal length of 50mm (wider angle lenses will not work as effectively) and a large maximum aperture. You will also need to use a lens that has a manual aperture ring rather than relying on an electronic contact, otherwise you will find that you can only shoot at maximum aperture. A prime lens is also preferable to a zoom, but it's worth noting that as you aren't attaching the lens to your camera, it doesn't need to be the "correct" fitting—you don't need to use a Nikon F-mount lens on your Nikon camera, for example. With all of this in mind a manual focus, 50mm ƒ/1.8 lens is ideal, and there are countless options that are readily available at a low cost on eBay.

WARNING

Whether you are looking through the viewfinder or using your camera's Live View mode to take freelensing photos, the film or sensor is directly exposed to the outside environment: the further the lens is from the camera body, the more likely dust is going to get into your camera. If you are not comfortable with this, then freelensing may not be the project for you.

LIGHT LEAKS

With your lens detached, ambient light can easily get into the camera. These light leaks are one of the characteristics of a freelens image and indoors—or on a cloudy day outside—they can enhance the vintage feel of your shots. However, on a sunny day these leaks can be so intense that they become problematic, in which case you can cover up the gap with your hand to try to reduce the effect in your image-editing program.

Tilting the lens as you hold it in front of your camera will introduce a tilt/shift look that's ideal for creating "miniature worlds."

GETTING STARTED

To start freelensing, set your camera to Manual and make sure that the shutter will fire without a lens attached; you may need to enable this in the camera's menu. If it isn't already removed, detach the lens and hold it close to the camera body, leaving a small gap between the camera and lens (a gap of a few millimeters will suffice). Adjust the position of the focus by moving the lens in front of the camera, as outlined on the following page, either looking through the viewfinder or using live view to guide you.

The aperture affects the depth of field and exposure as it usually does, but a good rule of thumb is to always start at the widest aperture setting, just so you can get a sense of the shallowest depth of field available with your lens (the widest aperture allows the greatest amount of light through the lens, so you don't necessarily have to worry about using a slow shutter speed). If you want a larger depth of field, adjust the aperture accordingly—the exposure can then be set using the shutter speed and ISO.

FOCUS

The most important (and the most difficult) element in freelensing is setting the focus. It is a good idea to start with infinity focus, and then to adjust the position of the focus from there, either by turning the focus ring or moving the lens. When the subject is close to you, the focus can be adjusted using either method, but when the subject is far away focusing only works when it is set to infinity. If you set the focus below infinity it will result in a totally out-of-focus image, so the only way to adjust focus in this case is by moving your lens. Tilting the lens—even slightly—will shift the focal point and change the whole composition of an image, so you can find yourself juggling the focus and composition to determine the point at which both elements are balanced.

Even if you focus carefully, do not expect your shots to turn out as sharply as they do when the lens is attached to the camera. Freelensing distorts how light is focused onto the film or sensor, and this compromises sharpness. Sharpness is most affected when the subject is far from the camera. A related issue is motion blur, and this is especially common in low-light shooting. Because you are holding the lens off from the camera, the smallest movement can be recorded by a long exposure, and even a tripod may not help: it will reduce any camera shake, but not any lens shake.

Aside from focus fall off, you will also likely notice a dark edge (vignette) on the side of the photo where the lens is furthest from the camera. These dark edges might be a problem when the subject you're trying to focus on is very far away and you want to tilt the lens: the further you tilt the lens, the larger the dark edges become. This is when post-processing comes in handy.

POST-PROCESSING

First, let's deal with excessive light leaks. These can usually be reduced by increasing the contrast of the photo, and it's fair to say that many freelensing photos require a contrast boost, especially as this can also make the image appear sharper. Dark edges can also be dealt with in a straightforward fashion. If the darkening is slight, it can be treated as a vignette, with your image-editing program's vignette removal/reduction tools usually proving sufficient to counter the edge shading. However, when the dark edges are taking away too much of the image, or are too dark for your vignetting correction tools, cropping may be the only answer.

09 SINGLE CAMERA STEREO

Stereo photography is almost as old as photography itself. Early stereoscopic cameras were designed to replicate human vision, by producing two images on the same plate using two lenses positioned close to each other. However, the small distance between the lenses resulted in a low horizontal deviation between the images, which can often create a dissatisfying depth effect. To experience this effect, close one eye and move your head sideways to the left and right (but not up or down). The only spatial information your brain realizes is through the objects moving relative to each other, and the further you move your head, the better your understanding of the scene in front of you becomes. Stereo photography is much the same.

Recreating three dimensions in a two-dimensional photograph doesn't necessarily require you to use a camera with two lenses (or two cameras mounted side-by-side)—you can also shoot stereo images with a single camera, moving it sideways between shots to create a "stereo pair." The obvious disadvantage is that your images will be taken moments apart, so it's not going to work with subjects that are moving. However, for static subjects the benefit is equally obvious: you only need one camera.

WHAT YOU NEED
- Camera
- Computer running Windows
- StereoPhoto Maker software (Freeware from http://stereo.jpn.org/eng/stphmkr/)

DIFFICULTY ★ ★ ★

TIPS

Start by choosing a scene that is both interesting and offers lots of detail in terms of subjects. Scenes that have a natural "depth" are also preferable.

As you are only using one camera, moving objects are going to spoil the 3D effect. If you are shooting outdoors, avoid including trees or water unless there is complete calm.

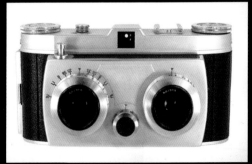

Below: A traditional stereo camera is a specialist camera with two lenses that emulate the way in which our eyes see the world.

Left: Architectural subjects are a good starting point for stereo photography with a single camera.

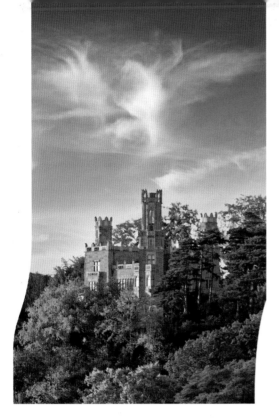
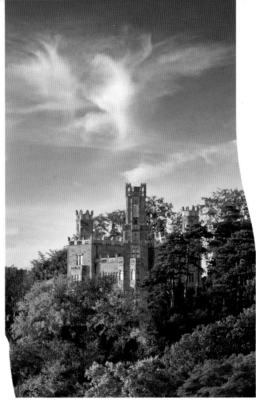

SHOOTING

You will save yourself a lot of time if all of your pictures of a certain scene are taken using the same camera settings, which is most easily done by switching your camera to manual exposure and manual focus. The key thing is to make sure that the depth of field remains consistent for both shots in your stereo pair, so if you don't want to shoot manually, consider using Aperture Priority and using your camera's Automatic Exposure Lock (AEL) feature in conjunction with focus lock.

With your exposure and focus set, the next stage is to take a number of images of your subject, moving the camera sideways between shots. Just how far the camera needs to be shifted to the side involves geometry and a precise measurement of the distances between the lens and the objects of interest, so it is advisable to rely on intuition and observation instead, as well as shooting several images to make sure you get a good pair.

Take the first shot with your camera in portrait (upright) orientation and then move it horizontally and take a second image. Repeat this until you have taken at least three pictures, with the camera moving sideways between shots. You can shoot even more images of the same scene if you want to: the idea is that by moving the camera after each photograph you will produce a series that will contain two pictures with the stereoscopic depth you desire when they are combined.

Processing your image sequences using HDR software and then creating a stereo pair adds another level of creativity to your shots.

TIPS

Shadows change rapidly in the evening and morning, so shoot quickly. Be aware also of other details that may be altering slowly, such as the hands on a church clock tower, for example.

Shooting Raw files will give you greater control over your results.

Create HDR stereo pairs by tonemapping your shots prior to combining them with StereoPhoto Maker.

If you have clouds in your picture and these change noticeably in your series, mask them out and replace them with a matching image of the sky.

PROCESSING

Having shot your images, you will need to combine them, and for this project we're using StereoPhoto Maker (SPM), which is Windows-only freeware, so it won't cost a thing. The first step is to make sure the program's preferences are set correctly, so start by choosing Preferences>Edit, and selecting the Adjustment tab. Set Input Image Arrangement to Cross, and select Mount Near Points To The Stereo Window. Enable both Better precision (Slow) and Auto Crop After Adjustment, and disable all other options.

Next, choose File>Open Left/Right Images. Navigate to the folder containing your shots and select two files of the scene while holding the Ctrl key. Then press Open. The option to view your stereoscopic pair side by side is available by pressing F9. Use the cross-eyed viewing method described on the page opposite to preview your image. If the stereoscopic effect seems flawed, press X to swap the images left to right (and vice versa), or choose a different image pair. When you're happy with the preview, choose Adjust>Auto alignment (Alt+A) to correct for any slight vertical shift between shots and SPM will optimize the images, creating a perfectly aligned stereo pair.

The customized frame shapes in this example were produced using Stereomasken software.

STEREO WINDOW VIOLATION

The "stereo window" is literally the frame that your stereo image sits in. Elements can be in front of this window, at the window, or behind it, and each will have a different effect on how the image is seen. You can control this in StereoPhoto Maker by using the left and right arrow keys to push your whole scene back or bring it forward. Be careful to avoid a "stereo window violation" though, which is where elements that appear in front of the window are cut off by the physical edge of the frame, diminishing the 3D effect. Software such as Bernd Paksa's Stereomasken can help you avoid this: you can download the program for free from www.stereomasken.de.

TIPS

After you have created your stereo pair, open the Border Options by pressing Alt+B and set L/R Space to 20. This will add a gap of 20 pixels between the left and right image, which will aid cross-eyed viewing.

Sharpening your stereo pair will help boost detail and enhance the 3D effect. You can access SPM's sharpening tool by pressing U: 25 is always a good value.

When saving your stereo pair in JPEG format, make sure to save it at a high-quality setting, so you don't lose detail due to JPEG compression. Any value over 90 is ideal, although saving your images in the PNG format will produce a completely lossless file.

VIEWING

You can view your three-dimensional images without any specialist tools or devices using the "cross-eyed" method:

1 Look at your stereo pair and cross your eyes until you see four blurred images. Repeat this a few times so you're familiar with the point at which you are seeing the pair doubled. Don't expect to see any detail in the photos at this stage.

2 Un-cross your eyes slowly. When your eyes are snapping back to normal there is a moment at which you will see three photos: try to hold your view here as long as you can and repeat this if necessary. Try to concentrate on the middle image only and it will soon appear three-dimensional, although possibly blurred.

3 The final step is to get the third image sharp. You can't force your eyes in focus, but by extending the time that you hold your view in the three-image position, your brain will realize that the third image can be seen in focus. This is just a reflex that will arrive.

If this viewing method doesn't work, try placing white paper around the image pair so you are not distracted by surrounding details. Alternatively, try adjusting your viewing distance to see if that makes a difference and/or your viewing angle (you should be straight-on to the stereo pair). If this still doesn't work, try again after resting your eyes, but above all be patient—it may take a while to become accustomed to "seeing" photographs in 3D.

The moon has inspired poets and painters for centuries, but there's no reason why photographers shouldn't get in on the act too. However, why stop at shooting just one moon? With a dash of photography magic you can create a striking image of multiple moons rising across the sky, in just one shot.

The effect is achieved by locking the shutter of your camera open and then regularly covering and uncovering the lens with an opaque cloth until the sequence is complete. The length of time between each exposure will depend on how much space you want between each moon in your image. As a guide, the moon moves a distance equal to its own diameter approximately every two minutes, so if you want the distance between each moon to be equal to its diameter you'll need to make an exposure every four minutes. Using a timer of some sort will help you maintain a consistent distance between each exposure.

The focal length of your lens is an equally important consideration as it will determine how many images of the moon you'll be able to fit across your image, and their size: the longer the focal length, the fewer moons you'll be able to fit in, but the bigger they will be in the image. With a 300mm lens on a full-frame camera (200mm on a camera with a cropped-sensor camera) you should be able to fit approximately eight moons diagonally with an exposure made every four minutes. A wider focal length lens will mean that the moon will be smaller in the image, but you will fit more of them in, so you'll need to make a greater number of exposures (or allow a longer length of time between each exposure) to create a sequence that stretches across the frame.

NOTES

As you will be shooting in relatively cool temperatures, outdoors at night (and using long exposure times), I would highly recommend a freshly charged battery.

The closer the moon is to the horizon, the dimmer and redder it will become. It will also be affected more by the atmosphere and appear less sharp.

Shooting with an aperture smaller than $f/8$ will increase your individual exposure times, making it easier to time your shots correctly. However, you will need to be careful that the moon doesn't become blurred due to movement.

Thin, high-altitude cloud can create interesting effects as it passes in front of the moon.

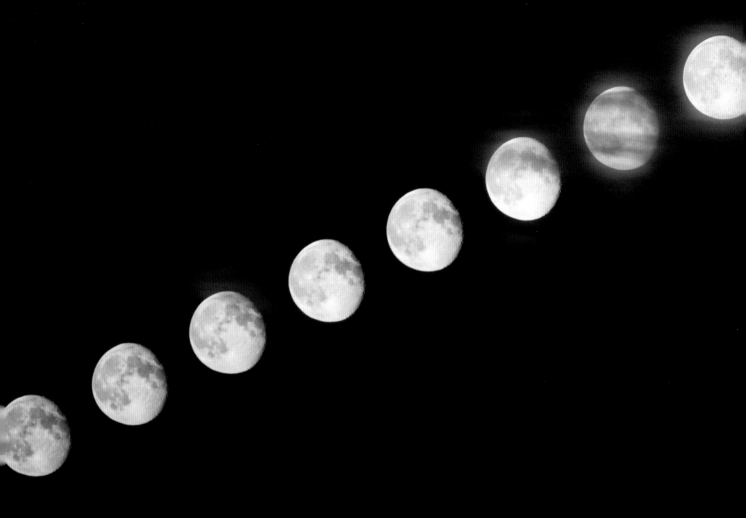

SHOOTING

1 Pick a night when the moon is set to rise after sunset. There are numerous moonrise calculation apps available for smartphones that will help you determine which night to choose, as well as telling you the direction the moon will rise.

2 Mount your camera on a tripod, switch to manual focus, and set the focus to infinity.

3 Set your camera to Bulb mode, the aperture to ƒ/8, and the ISO to 100. Position the moon in the bottom left corner of the frame and cover the front of the lens with an opaque cloth that can be easily and quickly lifted and dropped back in position again.

4 Open the shutter and lock it open using a remote release. Briefly lift the cloth to make your first exposure. How long your exposure needs to be will vary depending on atmospheric conditions, the phase of the moon, and how close it is to the horizon. A full moon is far brighter than a crescent moon, so requires a shorter exposure: 1/15 second compared to 1/4 second or even 1/2 second, for example. If possible, experiment to determine the correct exposure before starting your moonrise sequence.

5 After your predetermined gap between exposures (four minutes, say) make another exposure. Continue covering and uncovering the lens until you're satisfied that your sequence is complete and then release the shutter on your camera.

Over the course of a night the stars appear to move across the sky, although as you know, this is entirely due to the earth's rotation. If you were able to watch the night sky over a period of twenty-four hours (which is possible at either pole around the winter solstice), the stars would appear to circle around the sky, eventually returning to their start point. In the northern hemisphere the stars appear to rotate around the Pole Star, or Polaris, found in the constellation of Ursa Minor, while the nearest equivalent in the southern hemisphere is Sigma Octantis in the constellation of Octans, although it is relatively dim compared to Polaris.

With a sufficiently long exposure it's possible to record very striking images of star trails, and the longer the exposure, the longer the arc of the star trails. Unfortunately, digital cameras are far from perfect for this. The main reason is the presence of detail-reducing noise caused by random fluctuations in the camera's circuitry during long exposures: the longer the exposure, the worse the problem.

A straightforward way of overcoming this is to shoot a high number of shorter exposures and then blend them together in post-production. Enfuse, by Photographer's Toolbox, is a plug-in for Adobe Lightroom that allows you to do just that (Enfuse is donationware, and Lightroom is available as a free trial). To create your sequence you'll need to use a tripod to keep your camera steady (it's vitally important that your camera doesn't move between shots or you'll get distracting "jumps" in the blended star trail). It's also a good idea to use a high capacity, formatted memory card (particularly if you shoot Raw) and to start with a fully charged battery. Finally, you'll need to use a remote release with an intervalometer function that will automate the shooting of the sequence.

WHAT YOU NEED
· Tripod
· Remote release with intervalometer
· Adobe Lightroom
· Enfuse plug-in (www.photographers-toolbox.com)

DIFFICULTY ★ ★

TIPS

You can shoot either JPEG or Raw, but Raw is preferable, especially if you want to make the most of Lightroom's image-editing features.

Depending on how well your camera copes with long exposures (in terms of noise) you may be able to extend your individual exposure times from 30 seconds to one or two minutes. If you use a longer exposure, you will probably need to set your camera to Bulb mode.

Keep your camera set to its base ISO for maximum image quality, or increase the ISO to make fainter stars visible in each frame of the sequence.

SHOOTING

You'll be exposing shots for a lengthy period of time so choose a night when the weather is settled and there will be clear skies for several hours. It's a good idea to pick a moonless night so the stars aren't lost in the glare of the moon, but this may mean you have to set your shot up at dusk while there is still some light in the sky. A flashlight is useful to help see the controls of your camera clearly when the light finally goes.

With your camera on a sturdy tripod, switch to manual focus and focus on infinity. Switch your camera's drive mode to Continuous and the exposure mode to Manual so you have absolute control over the aperture and shutter speed. Set the aperture to f/2.8 (at ISO 100) or f/4 (at ISO 200) and the shutter speed to 30 seconds—this is often the longest shutter speed that can be selected manually.

Make sure that your in-camera noise reduction is turned off and set the intervalometer on your remote release to expose an image every 31 seconds (your camera will require a short period of time to write each image to the memory card). Then, set the required number of shots on the remote release—for an hour's worth of images you'll need to take 116 shots. Start exposing, being careful not to knock the camera during the shooting of the sequence.

BLENDING

1 Import your images into Lightroom. Highlight the entire sequence and then go to File>Plug-in Extras>Blend exposures using Enfuse/LR.

2 Click on the Auto Align tab and uncheck Automatically align images before blending them (as there should be no movement in the sequence other than the stars, leaving this option switched on will lengthen the processing time unnecessarily).

3 Click the Enfuse tab and drag the Exposure weight slider to 1.0. Drag the Saturation and Contrast sliders to 0.0. Setting the sliders this way is a good starting point, but every image is different so experiment with the slider positions if the results aren't what you were expecting.

4 Click on the Output tab and set the options according to your personal preference. As the blended image may need some adjustment afterward it's highly recommended to set Format to TIFF, Bit Depth to 16-bit, and Color Space to Adobe RGB or ProPhoto to maintain maximum image quality. Checking Reimport image into Lightroom is recommended if you prefer to use Lightroom to edit your images, otherwise set Open blended file to your usual image editor.

5 Finally, click on the Enfuse Images button at the bottom of the Enfuse dialog to start the blending process. The number of images you've selected for blending—and their resolution—will have a significant impact on how long this process takes: the more images, and the higher their resolution, the longer the blending takes. However, once it's finished your blended image is ready for you to fine tune in your editing program.

Overleaf: The advantage of shooting a sequence of images to stack, rather than making a single long exposure, is that noise in the final image is (relatively) better controlled.

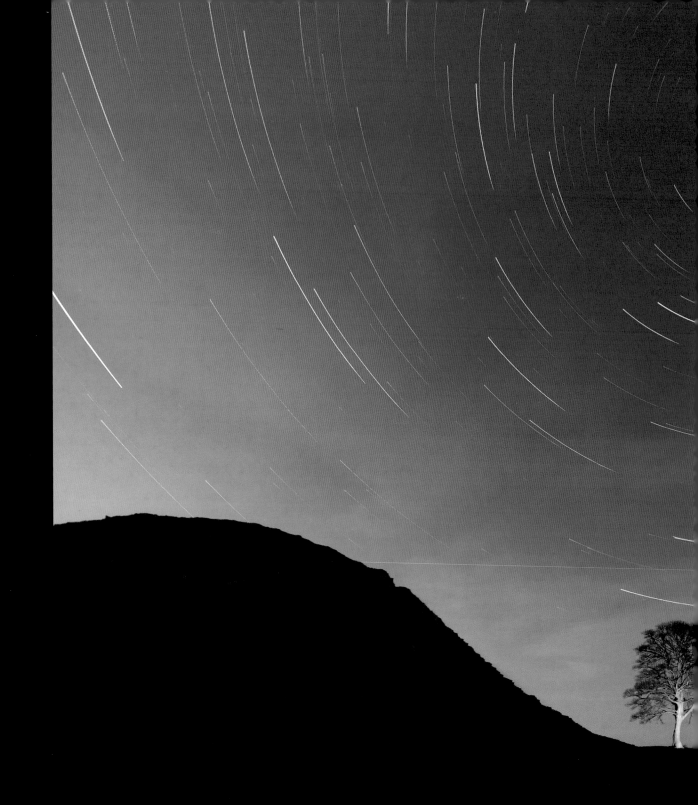

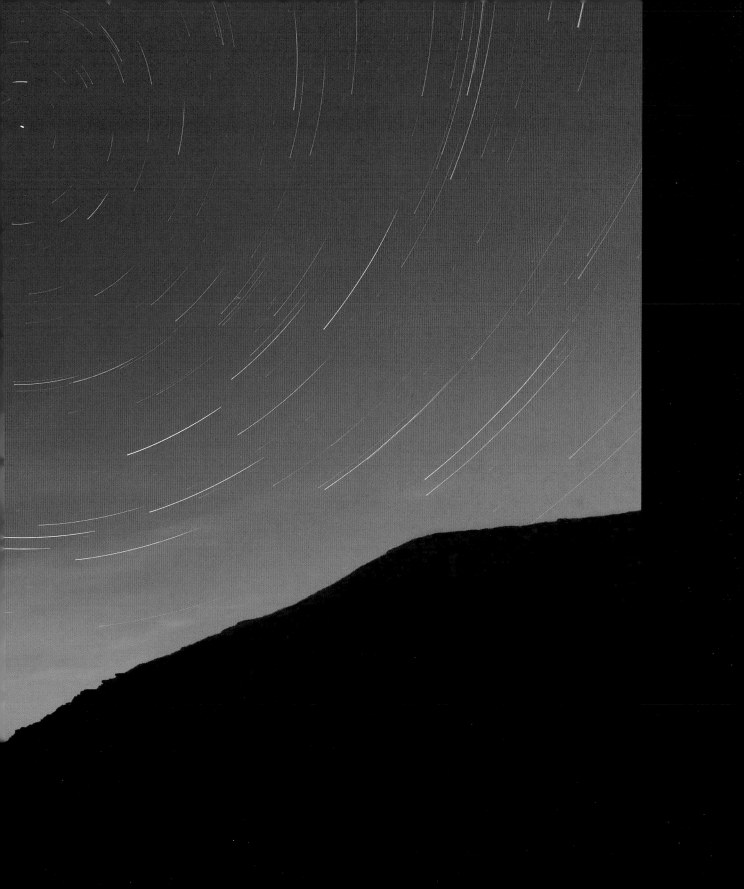

Depth of field is incredibly narrow in macro and close-up photography, even when you set your lens to its smallest aperture setting; and the closer you're focusing, the shallower it will become. This can't be overcome optically, but there is a digital method that can be used to increase the apparent depth of field: focus stacking.

The technique involves taking a sequence of shots at slightly different focus points and then combining them so that only the sharply focused area in each image is used. "Stacking" the images in this way creates the illusion of an increased depth of field, and it's something that is relatively easy to achieve, providing you get the shooting side of things right to start with.

NOTES

The key to focus stacking relies on making sure that every part of the image is sharply focused in at least one shot in the initial sequence, and that means using manual focus, rather than relying on your camera's AF system. If your focus "misses" part of the subject, you will get a soft spot in your final image.

As well as increasing the depth of field in macro and close-up subjects, focus stacking can also be used to create an "infinite" depth of field in other shots, such as landscapes, where the focus stretches from the lens' closest focus point all the way to infinity.

Although Photoshop will enable you to stack your shots, there are also programs dedicated to focus stacking, such as Helicon Focus. To find out more or download the free 30-day trial, visit www.heliconsoft.com.

1 Focus stacking starts at the shooting stage, which is why it appears in this chapter. This is a critical part of the process, because if you get it wrong, your image will be less than perfect.

The aim when you're shooting is simple: to record a sequence of photographs with slightly different focus points. The key is to make sure that each area of the image that you want to appear sharp in the final composite is "in focus" in at least one shot in the sequence. To achieve this you will need to switch your lens to manual focus (and possibly manual exposure) and have your camera mounted on a tripod. If anything moves between frames you'll need to start again.

For the Jurassic image I'm using here, twelve shots were taken. The sequence started with the focus on the very front of the subject, shifting gradually back to the leaves in the background.

2 Once you've shot your images, you need to open them. I'm using Photoshop here, but I'm going to open them via Adobe Bridge by selecting the 12-shot sequence and choosing Tools>Photoshop>Load files into Photoshop Layers. This will open all of the shots in the sequence as individual layers in a single Photoshop file.

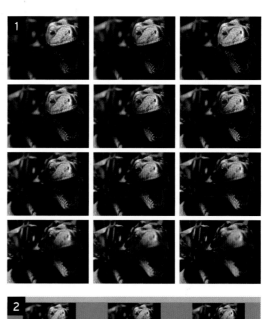

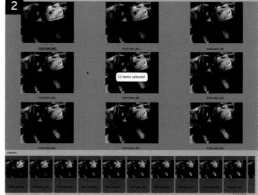

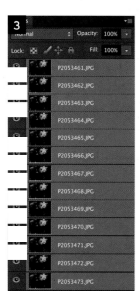

3 In Photoshop, open the Layers palette and select all of the shots in your sequence by holding down the Shift key and clicking on the first and last layer in the stack.

Choose Edit>Auto-Align Layers and then select Auto from the Projection options, before clicking OK. Photoshop will now align all the layers. This can take a while if you've got a lot of high-resolution images in your sequence, but it should be considered an essential step, as it will correct any minor movement that's occurred between shots.

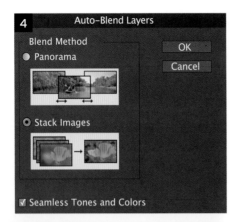

Once Photoshop has aligned your sequence, it's time to blend it. With all of the layers still selected, choose Edit>Auto-Blend Layers from the main menu. From the Auto-Blend Layers dialog, check Stack Images and Seamless Tones and Colors before clicking OK.

Blending the images takes even longer than aligning them: for this 12-shot sequence, the wait was a little over five minutes. Sure, my computer's not the fastest out there, but it isn't the slowest, either!

Photoshop has now gone through all of the layers and determined which areas are the sharpest in each, creating a mask for each individual layer so that it only reveals the focused elements. Combining these masked layers is what creates the overall impression of a much greater depth of field. At this stage, you can edit each individual mask, and crop the image if the aligning and blending processes have resulted in an irregular edge.

Once you've edited your masks, you can flatten the layers and process your image as you would any other photograph: applying Levels or Curves adjustments, fine-tuning the color, or converting to monochrome for example. Here, a simple crop to a square shape was the only additional editing.

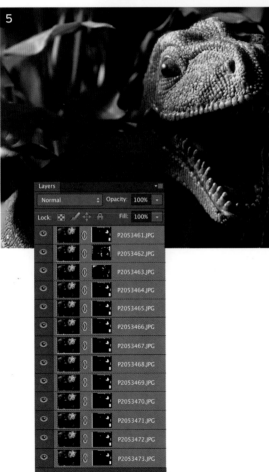

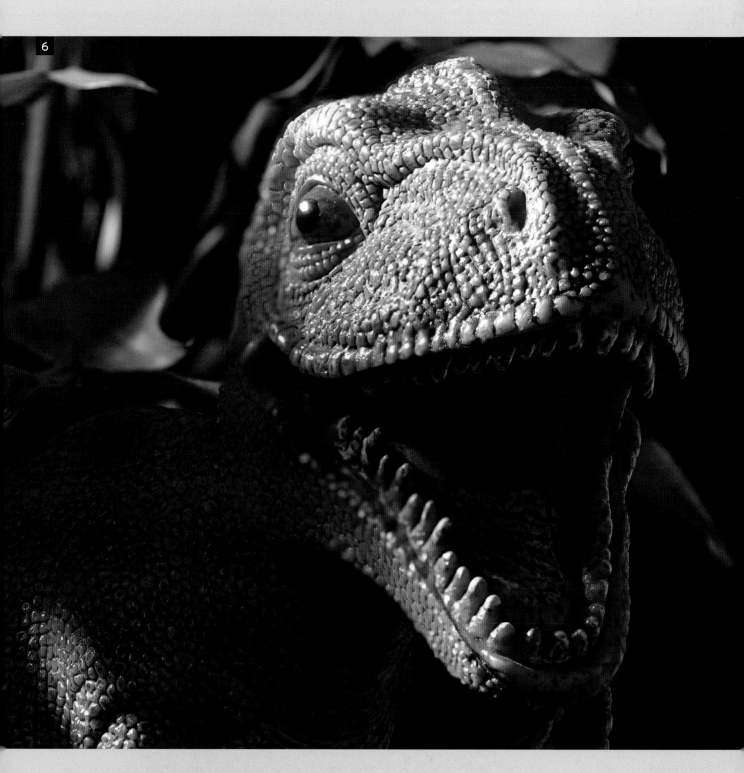

6

Most point-and-shoot compact cameras will allow you to reveal small, often unseen worlds by taking close-up shots, but even the most powerful macro facility pales when it's compared to the magnifying power of a microscope. Serious micro photography (correctly known as photomicrography) requires equally serious equipment, but what about trying "lo-fi micro?"

Just as plastic cameras such as the Holga and Diana can produce striking results through less-than-perfect optics, so low-cost "toy microscopes" can provide you with ultra-close-ups for minimal outlay. You may not get tack sharp results (or even marginally sharp shots in some cases), but the creations formed by heavy magnification and low-tech optics can make great abstract images.

THE SETUP

For this project, the microscope you want is more likely to be found in a toy store than a high-school biology lab: the National Geographic-branded microscope used here came from the kids' pages of a catalog and cost less than $40.

To connect the camera to the scope simply requires a tube of some description. I'm using a 2 1/2-inch/7cm-long piece of pipe-insulating foam, which is not only dense enough to hold its shape with a camera attached, but the hole is also a near perfect match to the diameter of the microscope viewing tube. A hose clamp holds the foam on the microscope and another clamp holds the camera lens, but be sure not to tighten the clamps too much, especially if you've got a plastic microscope and/or camera.

SHOOTING

Once your camera's mounted you can start to explore your new world, and it's not that different to regular photography. Set your camera to its macro focus setting and focus the microscope using the preview on your camera's LCD screen as a guide. Use your camera's self-timer to trigger the shutter in order to avoid camera shake, and review shots as you take them: assess the histogram and tune the exposure settings as well.

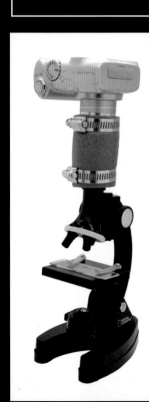

Right: The setup, consisting of a "toy" microscope and a short tube to connect the camera.

Left and Opposite: The subject as seen under the microscope, and the finished abstract image after it has been cropped, rotated, and had the color boosted.

LIGHTBOX SHOTS

When photographers didn't have any choice but to shoot on film, a lightbox was an intrinsic part of any studio, allowing transparencies and negatives to be viewed and assessed, and decisions to be made over which was the "best" frame. With digital photography this is no longer necessary: images can be reviewed instantly on the camera's LCD screen, or on a computer monitor instead.

However, while a lightbox is of no use when it comes to reviewing digital images, it can certainly be useful in creating those images in the first place. For example, stand a lightbox on its side and you've instantly got a flat, diffuse light source: a less bulky, and often more convenient alternative to a softbox if you're shooting small-scale subjects. Alternatively, lie a softbox flat and you can place items on top of it to create a "quick and dirty" white background that, in most instances, just needs the addition of a few strategically-placed reflectors to light your entire subject. Or you could stand a lightbox behind your subject to act as a background—and not just white, either. Add a lighting gel and you can introduce a uniformly lit, single-color background without having to use any additional lights.

TRANSLUCENT OBJECTS

Objects that are naturally translucent can make great subjects for lightbox shots, with the back-lighting revealing them in an entirely new way. The key to successful shots—as with most subjects—is getting the exposure right. In this instance it often means switching to your camera's spot meter option so that you can take a meter reading that isn't affected by the bright white background. Although this will prevent your camera from underexposing the subject heavily, you may find that you also need to use exposure compensation: +1EV is a good, general start point.

If your camera doesn't have a spot meter mode, use its center weighted option instead (or multiarea metering) and dial in a greater amount of positive (+) exposure compensation to lighten the image.

WHAT YOU NEED
· Camera
· Lightbox or light table (see Project 38)

DIFFICULTY ★

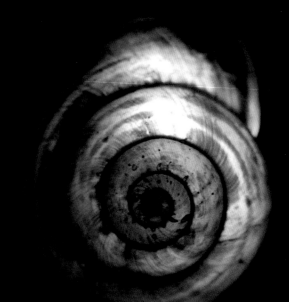

Below: Although the background is black, this translucent snail shell was actually photographed on a lightbox. A hole that was slightly smaller than the shell was cut into a sheet of black card, which was then placed on the lightbox, creating a pure black background with a bright "spot" of light. The shell was placed over this spot, and the light from the lightbox effectively illuminated the shell from the inside to reveal the detail.

Above: The size of your lightbox will determine what it can be used for: the larger the surface area, the larger your potential subjects can be.

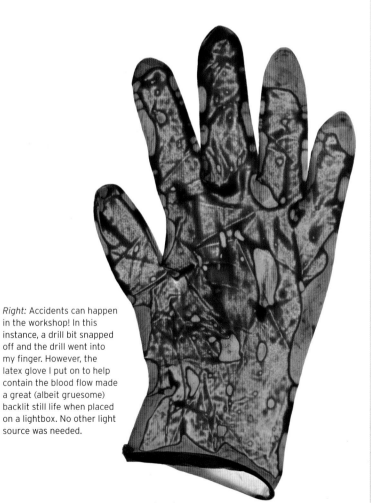

Right: Accidents can happen in the workshop! In this instance, a drill bit snapped off and the drill went into my finger. However, the latex glove I put on to help contain the blood flow made a great (albeit gruesome) backlit still life when placed on a lightbox. No other light source was needed.

X-RAY EFFECT

This black-and-white shot of a translucent plastic water pistol was originally photographed on a lightbox with a plain white background (below).

It was quickly transformed into a pseudo X-Ray using Photoshop. Inverting the image (Image>Adjustments>Invert) turned the gun white and the background black, with a subtle blue color-tint introduced using Variations (Image>Adjustments>Variations).

Printing the image onto acetate would enhance the physical feel of an X-Ray, which could then be mounted and displayed on a custom-made lightbox or light table (see Project 38).

COLORED BACKGROUNDS

Photographing your subject against a brightly colored background is a great way of making it leap from the page and look less like a traditional packshot or "cut-out" style catalog shot. The easiest way to achieve this is with a colored lighting gel: these are available from photographic and theatrical stores, as well as online. Lighting gels come in myriad colors, and it's simply a case of picking the one that works best for your image and placing it over the lightbox: position your colored background behind your subject; place your subject above it (on a sheet of glass, for example); or put your chosen object directly on it.

If you're using additional lighting, take care that the lights you use on your subject don't fall on the lightbox and create potentially distracting highlights (gels are highly reflective). On the plus side, you may also find that because the background is illuminated, it naturally "absorbs" any shadows cast by the subject, which can work in your favor.

The intensity of the background color can be controlled through the exposure, and the color will be intensified by underexposing it slightly. However, as you can't do this by controlling the power of the lightbox, you will need to do it by controlling the ratio of your main light(s) to the background. Setting your main light so it is 1/2–1 stop brighter than the lightbox (and setting the exposure for your main light) will produce the strongly saturated background colors seen here.

Above: A gelled lightbox placed behind the subject will create a uniform background color in a very straightforward manner. However, tilting the lightbox, even slightly, can create a subtle graduated background instead: the brightness will decrease as the distance from the camera increases.

Right: These clockwork teeth were placed on a sheet of glass approximately 12 inches (30cm) above a green-gelled lightbox. The main light was 1/2-stop brighter than the background, which helped intensify the color.

The toy snail that became the subject of this photograph was found lying in the gutter, dirty and worn. Although it was once a deeply-saturated pink color, the elements had faded it heavily, and "as found" it wasn't the vibrant subject I wanted. However, inverting the original photograph transformed it into a deep, rich, blue-ish color. Rather than "cheat" and drop the background in at a later stage, a mid-green gel was used on the lightbox. When the colors were inverted (using Image>Adjustments>Invert in Photoshop), this became a strong magenta.

EQUIPMENT

Although it is ultimately the images you produce that count the most, achieving that end result is often easier if you're using the right kit. For that reason, there's a whole host of manufacturers out there who are looking to ply you with "must have" accessories to aid your photography. In many cases, these are indeed useful add-ons that will broaden the scope of what you can do with your camera, but these "little extras" can quickly become expensive when you start adding the costs together.

This chapter takes an alternative approach to the "buy, buy, buy" mentality and looks at ways of maximizing your equipment options by making your own. Sure, the end result is not always as refined or pretty as a commercial alternative, but at a fraction of the price it's often hard to complain.

15 CAMERA SLING

A camera strap is pretty much taken for granted if you want to take an SLR camera or CSC out and about and have it ready to shoot at a moment's notice. However, the traditional attachment method—two eyelets on the top of the camera—can get in the way at times, especially with digital cameras and their numerous control points. A camera sling alleviates this problem by attaching to the bottom of the camera, utilizing the tripod mount to keep the strap out of the way of your buttons and dials. Worn diagonally across the body, from shoulder to hip, it can also make carrying your camera more comfortable as well.

1. Start by checking that your bolt will fit through one of the holes in the angle bracket. If it doesn't, use your drill with a 1/4-inch or 6.5mm drill bit to enlarge the hole. Make sure that the bracket is clamped firmly while you drill it, and don't forget your eye protection—a metal shard in the eye isn't fun!

2. With the hole enlarged for the bolt, check that your strap will fit the other hole in the angle bracket. You only need to make sure that one of the strap's clips fits the hole, but if it doesn't (or doesn't fit comfortably) you'll need to reach for your drill again. Take your time and use a slow speed setting to keep the friction (and heat) to a minimum—this will help extend the life of your drill bit.

3. Once your angle bracket is cool enough to handle, you can put your sling together. Start by bolting the angle bracket to the tripod socket of your camera, using a washer between the bracket and camera if you want to. I'm using a fiber washer here, simply because I had a stash in my workshop. You can also use thread-locking fluid on the bolt to make sure it doesn't work itself loose.

4. Attach one end of the strap to the other to create a loop (I'm using an old-school Olympus camera strap for this project) and then clip the free end of the strap to the angle bracket on the camera. Adjust the length of the strap so your camera sits comfortably and you're good to go!

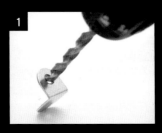

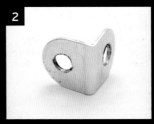

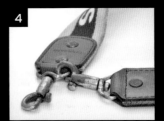

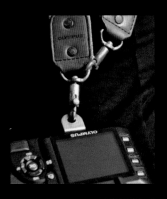

NOTES

All small-format cameras (film and digital) use a 1/4-inch UNC tripod thread with 20 threads per inch. If you're looking for a suitable bolt, this is often written as 1/4-20 UNC, followed by the length of the bolt.

Use a strap with metal and not plastic ends. Metal is much stronger so will increase the longevity of the sling.

A camera sling can also be used with a compact camera. This is more convenient than the wrist strap this type of camera often comes with.

A tripod is great for holding your camera steady, but if you're using a compact camera rather than a full-blown SLR kit–and you mostly want to "point and shoot"–then it's not something you want to take out with you, especially if it's big and bulky. Even a portable "travel tripod" can be overkill on a casual night out. However, this doesn't mean you have to rely on steady hands to keep your low-light shots sharp –in just a few minutes you can transform the cap from a regular soda bottle or water bottle into a drop-it-in-your-pocket, go-anywhere compact camera support.

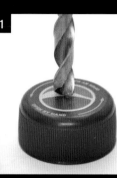

1

2

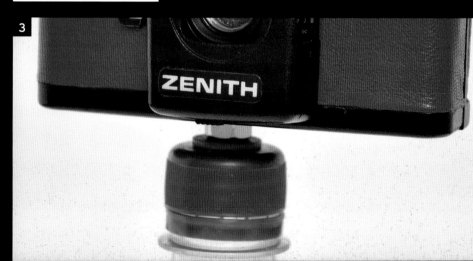

3

1 The first step is to grab your drill and make a hole in the center of the cap, going all the way through. Most bottle caps have a molding mark on the outside at the center of the cap, which is great because you can use this as a mark to aim your drill. Use your craft knife to tidy up the edges of the hole if there's any ragged plastic.

2 Slide your bolt through the hole from the inside of the cap and fit the washer (if you're using one), followed by the nut. I'm using a 3/4-inch long socket cap bolt and a fiber washer for my bottle pod.

3 Tighten the nut until you're happy everything's secure, and that's it done! All you need to do when you want to use it is to buy a bottle of soda or water, swap the regular bottle cap for your bottle cap 'pod, and attach your camera. A full bottle will provide a surprisingly stable support that's perfect for low-light shots in a bar or club, or simply when you're out and about.

We all know how important it is to hold your camera steady when you shoot. It doesn't matter if you're shooting still images or recording movies, a camera that's moving around isn't likely to produce great material: still images will likely be blurred due to camera shake, while video footage can bounce around and make your audience nauseous. The traditional method for holding your camera still—beyond good camera technique—is to mount it on a tripod, or use a monopod or beanbag as a support, although in-camera image stabilization can also help if you're shooting handheld.

These are all great options, but they are not always that practical or versatile, which is where this project comes in: the quick clamp. Utilizing a large clamp, we're going to produce a lightweight camera mount that can be attached to railings, tree branches, or any number of other objects, to guarantee rock-steady images or video footage.

TIP

The heavier your camera is, the more robust the clamp you use will need to be. The 8-inch clamp used here will hold a digital SLR and standard zoom lens, but a lighter clamp would be OK to use with a point-and-shoot camera.

1 The main ingredient for this project is the clamp. I'm using the sort of heavy-duty plastic clamp that can be found in a dollar store or hardware store: I got a pack of 12 mixed sizes for under $10, including two of these giant, 8-inch long versions.

2 Take your drill and make a 1/4-inch hole at the top of one of the handles, near the end. I lucked in with this clamp: it already has a pair of small holes in the right place on each handle, so I just needed to make one of the holes larger. Because you're drilling plastic, this is pretty quick.

3 Next, fit your 1/4-20 bolt through the hole from the "inside" of the handle, and put the washer on the outer side. If you want to, you can attach your camera directly to the bolt at this stage—just use more washers to act as spacers between the camera and grip if you need to shorten the thread of the bolt.

4 Alternatively, attach a mini tripod head instead of your camera. You can often pick up small tripods in yard sales or thrift stores for a couple of bucks—just make sure the head can be removed; is working; and has a 1/4-20 thread to attach it to the camera (some use a larger 3/8-inch thread).

5 With the head in place, you're good to go: just attach your camera, clamp it to a suitable and convenient object (think railings, tree branches, or anything similar to these), and you're guaranteed rock-steady images or video footage.

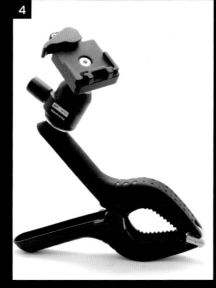

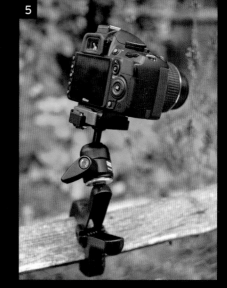

A quick clamp is ideal in the urban environment, especially in places where a tripod wouldn't be practical or allowed. In this example I used it to support the camera while I shot an HDR exposure sequence.

18 SUPER ND FILTER

By increasing your exposure times a neutral density (ND) filter can create incredible results, but they can be expensive, especially if you want to start stacking more than one filter for extreme exposure extension. However, if you have a spare screw-on UV filter (or filter adapter ring) and some strong adhesive, you're already 2/3 of the way to creating your own "Super ND" filter: all you need to add is a piece of welding glass.

As with regular ND filters, welding glass comes in different strengths, known as "shades:" the higher the shade, the less light passes through. A shade 10 welding glass is a good starting point for this project, as it will reduce the amount of light entering your camera by approximately 14 stops. You can get replacement welding glass from most welding supply stores, or online, and it should cost you no more than a few dollars. The only downside here is that you're going to have to work on your images to get the color right: welding glass isn't "neutral."

MAKING YOUR "SUPER ND" FILTER

To transform your welding glass into a filter, you will need a UV screw-fit filter (or a filter system adapter ring) that matches the diameter of your lens, and some solid-setting adhesive putty. Give the welding glass a thorough clean in a solution of warm water and washing-up liquid, and allow it to dry before buffing it with a lens cloth. Then, simply use the adhesive putty to stick the welding glass to your filter (or adapter ring), working it around the edges to make sure you prevent any light leaks. Allow this to cure overnight and your super ND filter is ready for action!

SHOOTING

The basic method of using your Super ND filter is no different to using a regular photographic ND filter. Start with the filter off the camera, so you can see as you focus and compose the shot. Then, select your camera's Bulb mode and the aperture you want to use, and make a note of the meter reading given by the camera. Set the lens to manual focus and hold the barrel still while you screw on your Super ND filter.

Now comes the tricky bit—determining the exposure. Assuming you're working with a shade 10/14-stop filter, work out roughly how long the shutter will need to be open based on the initial exposure reading. For example, if the meter reading is 1/30 sec without a filter, a 14-stop increase would extend this to approximately 500 seconds (roughly 8-8 1/2 minutes).

It goes without saying that you need to make sure the camera is steady for the duration of the exposure. A tripod is essential and it must be on a solid surface. To hold the shutter open for what could be several minutes, set your camera to Bulb and use a remote release. You could hold the shutter-release button down manually, but this is likely to cause movement during the exposure. When you have finished, look at the LCD and histogram to determine if you need to adjust the exposure time and reshoot.

WHAT YOU NEED
- Replacement welding glass
- UV screw-fit filter (or filter ring adapter)
- Adhesive putty

DIFFICULTY ★

NOTE

A major problem with long exposures is digital noise, and the longer the exposure, the more noise you will see in your final image. It is much better to shoot Raw files and apply noise reduction when you convert your images, rather than employing in-camera noise reduction and shooting JPEGs.

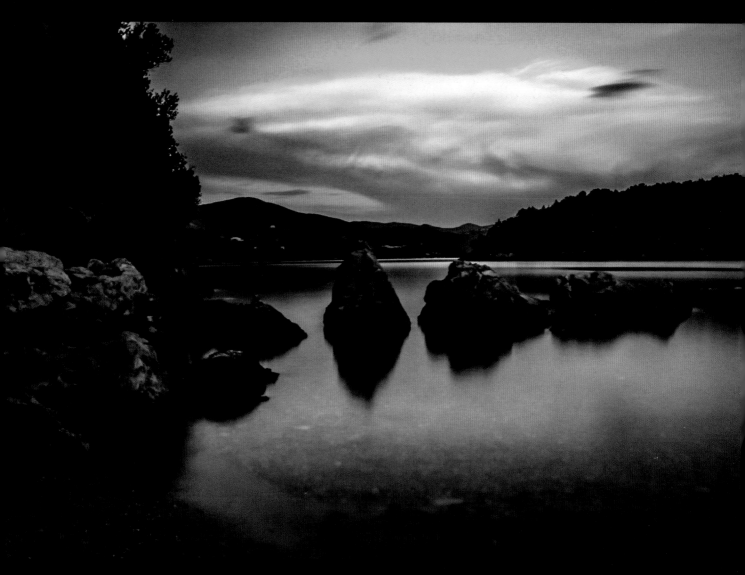

POST-PRODUCTION

Welding glass produces a strong green tint. You can try to
counter this using your camera's automatic white balance
setting, or by creating a custom white balance, but it's likely
that you will need to use your editing software if you want to
get an image with relatively natural colors. Adding magenta to
your image will usually help balance it out, although you may
also need to adjust the color temperature to get a more
realistic hue. Shooting Raw makes this a lot easier than
shooting JPEGs.

Your super ND filter can extend
your exposures considerably: A
shade 10 welding glass will reduce
the amount of light reaching your
sensor by 14 stops.

You can have the finest lens on the planet, with the very best coatings, but it's still guaranteed that if light strikes the front element at a certain angle you're going to suffer lens flare. In the past, you'd simply fit the lens hood that came supplied with your lens and that would be that, but today it's not quite so straightforward: some manufacturers don't include caps with all of their lenses; the long focal length range of some zooms makes the supplied lens cap all but redundant (the negligible shade provided at the wide end becomes wholly ineffective when you zoom in); and, of course, lens caps get broken and replacements are expensive. Yet all it takes is a sheet of black foam board, some hook and loop fastener, and a filter system adapter ring, and you've got all the ingredients you need to start building a bespoke lens hood "system."

WHAT YOU NEED
- Black foam board (1 x 11 x 14-inch/A3 sheet)
- Pencil
- Pair of compasses
- Hook and loop fastener
- Filter system adapter ring (see Tips)
- Glue

DIFFICULTY ★

TIPS

Use a filter adapter ring that matches the largest diameter lens in your collection, and fit stepup rings when you want to use it with smaller diameter lenses.

A five-inch square/125mm mount is ideal for wide-to-standard focal lengths, but for telephoto lenses you may want to reduce the size to prevent the shade from becoming overly long.

1 Start by cutting a five-inch/ 125mm square out of your foam board and marking its center. You can find the center by drawing a line diagonally from corner to corner: the point at which these lines intersect is the mid-point.

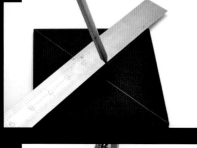

2 Take your pair of compasses and set the legs so they are slightly wider apart than the radius of your filter adapter ring (here I've set the compasses to 35mm for a 67mm filter ring). Draw a circle that is centered in your square piece of board and cut this circle out. Attach your filter ring to the camera and hold your black square of board against it, so that the top of the square is level. Make a pencil mark on both the board and filter ring so you can realign them at the next stage.

3 Stick the filter ring to your foam board square using double-sided tape. Centering the ring on the hole you just cut out, and align the marks you made in the previous step.

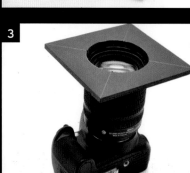

4 Cut another five-inch square out of your foam board, and then cut a four-inch square out of its center so you're left with a 1/2-inch wide frame.

5 Now you can make the hood itself. You need to know the optimum size for this, so mount your filter ring (and square black board) to your chosen lens and hold a ruler at the left (or right) edge of the board, pointing directly forward. Look through the viewfinder and slide your finger along the ruler until it enters the frame: that is roughly the size you want to make the sides of your lens shade.

6 Cut four rectangles of foam board measuring five inches multiplied by the measurement you noted above (here two inches) less around 20%. Once cut, trim two of these boards by a measurement that is equal to double the board's thickness (so trim off 3/8 inch if you're using board that's 3/16 inch thick, for example). This should be cut from the five-inch side of the rectangle, just so that there aren't any gaps when you join the sides together. Once cut, stick the four rectangles together to form a five-inch square box.

7 Glue your box to the 1/2-inch frame to create your "shade," and attach this to the filter ring mount using a tab of adhesive hook and loop fastener in each

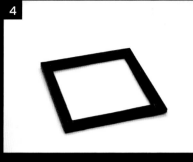

4

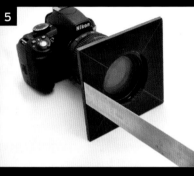

5

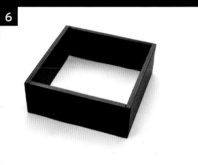

6

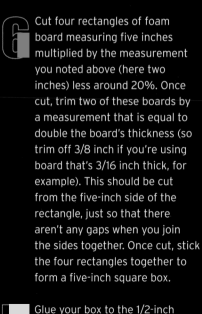

7

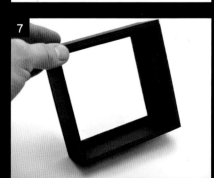

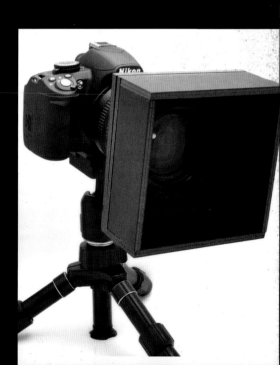

Although digital cameras have been around for a good 20 years now, and the technology has snowballed into the high-end cameras we have today, there is one area that hasn't changed that much: the reflectivity of the rear LCD screens. To be fair, manufacturers have a tough challenge: the screen needs to be protected from harm (clear plastic is the obvious choice), but as soon as light strikes this from an angle it becomes nearly impossible to see the image or shooting information on screen. As a result, a whole raft of supplementary screen shades is available, ranging from cheap, simple shades, through to remarkably sophisticated units. Alternatively, you can simply make your own, using foam board or thick card. As an added bonus, this design also includes a "flip-up" magnifier for checking the screen more closely.

WHAT YOU NEED
- Black foam board or thick card
- Glue
- Craft knife
- Credit card-sized magnifier
- Electrical tape
- Adhesive putty/sticky tack

DIFFICULTY ★

1 The first step is to measure your camera's LCD screen. Take a measurement for the top or bottom and one of the sides, and make a note of both so you know the size that the base of your screen shade needs to be.

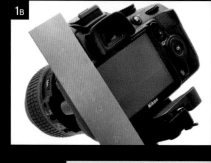

2 You also need to know how deep your shade should be. Switch on the rear LCD screen and hold the magnifier up to the screen. Move it slowly away until the image becomes unacceptably soft, then start moving it closer until you find the "sweet spot" in terms of focus. At this point, measure the distance from the screen to the magnifier and make a note of it.

3 The third and final measurement is of the magnifier itself. You will again need to make a note of the width and height measurements.

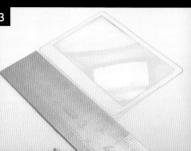

NOTES

Credit card-sized magnifiers are readily available via eBay for less than $1 each, although it's purely optional: you can use the shade without one.

There are countless ways that you can attach the shade to your camera if you feel sticky tack is not strong enough. Hook and loop fastener is one option, and tape is another. Alternatively, elastic bands can be used to hold the shade in place, so experiment to find the one that works best for you.

4 Armed with your three sets of measurements you can draw out the sides of your shade on your foam board, using the accompanying template as a guide. Note that you will need to add twice the thickness of your board to the top and bottom screen measurements.

5 Once drawn, cut out your panels with a craft knife and assemble them as shown, gluing the joints. You could also tape the edges to tidy them if you wanted to.

6 Use a strip of electrical tape to form a hinge that attaches the magnifier to the top of the shade. This will enable you to flip the magnifier into position when you want to use it, but also to flip it up and out of the way when you just want to use the shade on its own.

7 Finally, you need to mount the shade to your camera. By far the easiest way to do this is to use a sticky tack adhesive putty: a blob in each corner of the shade will be enough to hold your lightweight shade on the camera.

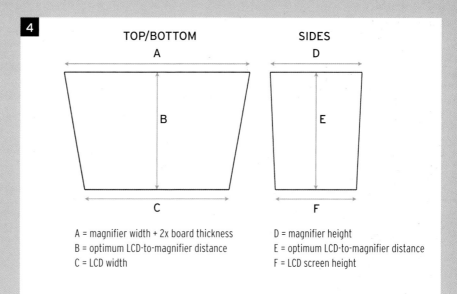

4

TOP/BOTTOM SIDES

A = magnifier width + 2x board thickness
B = optimum LCD-to-magnifier distance
C = LCD width

D = magnifier height
E = optimum LCD-to-magnifier distance
F = LCD screen height

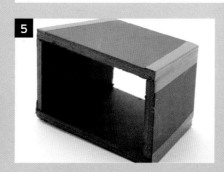

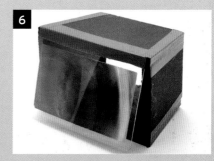

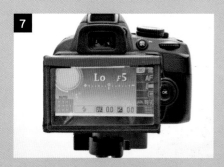

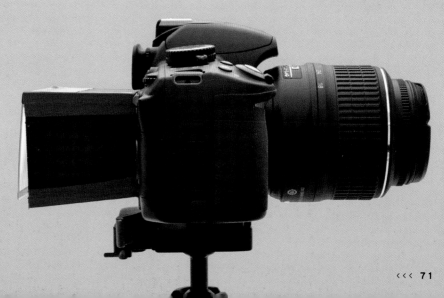

There are numerous tools that you can use to enable you to photograph small subjects, ranging from relatively inexpensive close-up lenses that screw to the front of a lens in the same way as a filter, through to dedicated macro lenses or reversing your lens so you shoot through it "back to front."

Alternatively, one sure-fire way to macro photography success is to move your lens away from your camera body, using extension tubes, macro bellows, or even a teleconverter to enable your lens to better record tiny objects. The idea of getting the lens away from the camera body is the basis of this project, which uses an empty potato chip tube as a low-cost "spacer."

1 Before you begin you're going to need to collect the various items you'll need: a camera body cap (that you'll effectively trash); a lens (a manual 50mm prime is perfect); some black cloth (I'm using an old sock); and an empty Pringles tube (or similar).

2 Start by taking your body cap and "coring" out the center. You will be using this as the lens mount for your tube, so work from the inside and remove all of the plastic inside the mounting ring (as marked). Use a Dremel, a drill, or whatever else will do the job.

3 Place your lens cap on the metal end of your Pringles can and mark the hole you've cut out. Using your preferred cutting tool, cut out the circle you've marked so you have matching holes in your body cap and chip can.

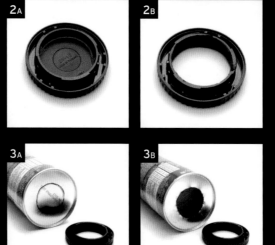

4 Take your glue gun or epoxy resin and mount your body cap to the chip can, aligning the holes you have cut in both. Clamp the two parts together while the glue dries.

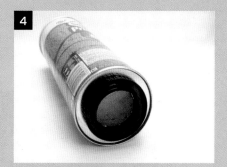

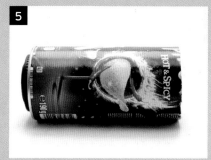

5 The next step is to cut your chip can to length. As a rough guide, the longer the tube, the closer you will be able to get to your subject(s). However, as the tube length increases, you will lose light, which will lengthen your exposure times. This, coupled with the physically longer tube, will increase the chance of camera shake, so a small amount of compromise may be needed. For this tube I felt that a length of 6-inches/15cm would give me the best overall performance with my 50mm lens, although the measurement doesn't have to be precise.

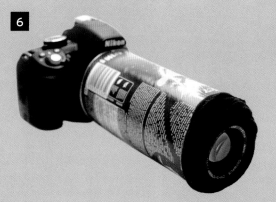

NOTE

To focus your macro tube you will need to move the camera or subject (the focus on the lens is redundant). You will likely need to determine your exposures manually as well: take a test shot and use the histogram to "chimp" your exposure.

6 To mount your lens to the tube, take your black cloth and wrap it around the lens barrel—how much cloth you need will depend on the diameter of the lens. The aim here is simple: you want to wrap enough cloth around the lens so that it fits snugly into your macro tube as shown. Try to make sure that the lens is relatively square in the tube.

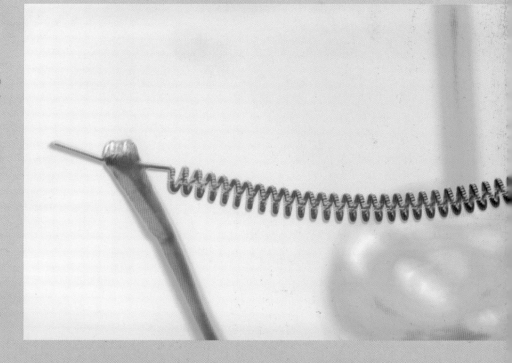

Right: The filament of tungsten lightbulb, photographed using a homemade macro tube and the "wrong" white balance.

22 LO-FI LENS

Although digital capture has effectively sidelined conventional film-based photography, analog capture still dominates one area: lo-fi photography. Championed by Lomography, Holga, and SuperHeadz, lo-fi photography is typified by plastic cameras that produce unique results thanks to their low-tech, often plastic lenses and no-frills specifications. These cameras aren't about producing technically superb results, where the focus is accurate to the nearest millimeter and the exposure correct to within one hundredth of a stop, but about celebrating optical imperfection and the "happy accident."

Shooting film isn't for everyone though: it's more expensive than digital capture, and it's becoming increasingly difficult to get film processed, not to mention actually buying it in the first place. Of course, you can try to emulate the lo-fi look with your image-editing program, but this can often look contrived, overly polished, and, well, just too digital.

In this project we'll be looking at a third option: combining a lo-fi camera lens with a hi-tech digital camera. In the past this would have involved a homebrew hack to physically remove the lens from a medium format camera and mate it to a digital camera, but today there's a much easier option: buy a dedicated lo-fi lens. There are two options, both based on classic lo-fi cameras: a Diana lens adapter (and lenses), or a Holga lens. But which one should you go for, and what should you expect? And how can you get the best from it?

LENS COMPATIBILITY

Use the following grid to determine which lo-fi lens options are available for your digital camera:

Lens mount	Diana adapter	Holga lens
Canon EF	YES	YES
Nikon F	YES	YES
Nikon 1	-	-
Olympus Four Thirds (SLR)	-	YES
Olympus PEN	-	YES
Panasonic Lumix G	-	YES
Pentax K	-	YES
Samsung GX	-	YES
Sony Alpha	-	YES
Sony NEX	-	YES

DIANA ADAPTER & LENSES

Introduced in the 1960s, the medium-format plastic Diana camera was originally used as a promotional tool or giveaway gift, rather than for "proper" photography. However, the quirky properties of its ultra-cheap plastic lens were soon seized upon by creative types and the lo-fi aesthetic that we know today was born, complete with heavy vignetting, focus fall-off, and the odd multiple exposure.

Although the original fixed-lens Diana was short lived, it was reborn when Lomography launched the Diana F+ in 2007. The latest incarnation displays many of the same characteristics as its predecessor, but one of the key differences is the crude bayonet system that allows the plastic lens to be removed and changed. There are currently five lens options—20mm fisheye, 38mm superwide, 55mm wide/close-up, 75mm "standard," and 110mm telephoto—and it was perhaps inevitable that a lens adapter would not be far behind, allowing them to be used on a digital camera instead of the medium-format film-based Diana+.

The Diana lens' lo-fi heritage makes it a logical option for your digital lo-fi escapades, but don't expect the same results when you switch to digital—far from it in fact. For a start, all of the lenses become "longer" due to the camera's sensor size, so the 38mm lens behaves more like a "standard" lens on a full-frame digital SLR, or a mild telephoto on a camera with an APS-C sized sensor.

In addition, Diana lenses are designed to deliver their "best" lo-fi results when they're used on medium-format film to shoot images measuring 5.2 x 5.2cm. On a digital sensor (be it full-frame or APS-C) you simply don't see the heavy vignetting and focus fall-off that typically appear at the edges of the frame as these lo-fi "defects" are effectively cropped out. Instead, you are left with a slightly soft-focus result instead—although some people may like this, it isn't a "true" Diana look.

This shot was taken using a Diana lens on a Nikon digital SLR. An aged effect has been added in post-production, but the lens exhibits none of the vignetting that characterizes the original Diana camera, just an overall soft focus.

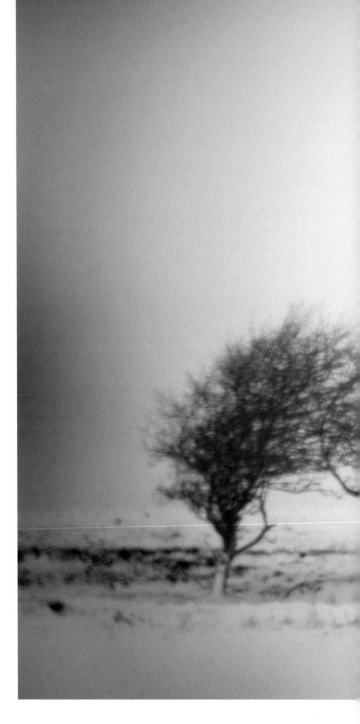

HOLGA LENS

The first Holga cameras appeared in China in the early 1980s, long after production of the original Diana had ceased. It was not intended as a Diana replacement though—it was instead designed to be a "camera for the masses" at a time when many Chinese families used medium-format 120 roll film. However, the primitive plastic-bodied, plastic-lensed snapper soon became popular with international photographers looking to get a lo-fi "edge" to their images.

Again, it was only a matter of time until the first "ready made" Holga lenses for digital cameras appeared, although it's fair to say that the first attempt was disappointing: for many photographers it simply wasn't as "lo-fi" as the analog camera's lens. In 2011, this was redressed, when a new "digital Holga" lens was released.

Unlike the Diana lenses, the iconic lo-fi Holga lens has been designed specifically for small-format digital capture, which has meant that all of the original lens' characteristics have been retained. This applies not only to cameras with full-frame sensors, but also on cropped-sensor formats as well, with the digital Holga lens exhibiting strong vignetting and focus fall off, as well as chromatic aberrations and lens flare.

There are some differences between an analog and digital Holga though. For a start, the aperture is fixed at a nominal setting of f/8, although in reality it is much slower than this, as explained below. Also, the 60mm focal length doesn't deliver the same wide-angle view that it does on a medium format Holga. Instead you get a slightly-longer-than-standard view with a full-frame digital camera, and a mild telephoto effect on cropped-sensor cameras (90-120mm depending on the camera you are using). However, that aside, the resulting images have a strong lo-fi appeal, and are certainly more in keeping with the original camera than the Diana lenses are.

EXPOSURE

It perhaps goes without saying that a low-tech lo-fi lens isn't going to house the sophisticated electronics used by a digital camera to determine the aperture setting, focus distance, and so on. With some cameras you will still be able to use TTL metering and choose between Aperture Priority and Manual, but with others you may have to rely totally on setting the exposure manually, and possibly without assistance from your camera's meter.

If this applies to you, then you could use a regular lens (or a handheld exposure meter) to take an exposure reading, and then dial this into your camera manually. However, you should be aware that the f/8 aperture of a Holga lens is much slower—roughly 4-5 stops slower in fact—so a Holga lens should be treated as if it has an aperture of f/45.

Alternatively, with a Diana lens you can use the "Sunny 16" rule: on a bright sunny day set the aperture to f/16 and the

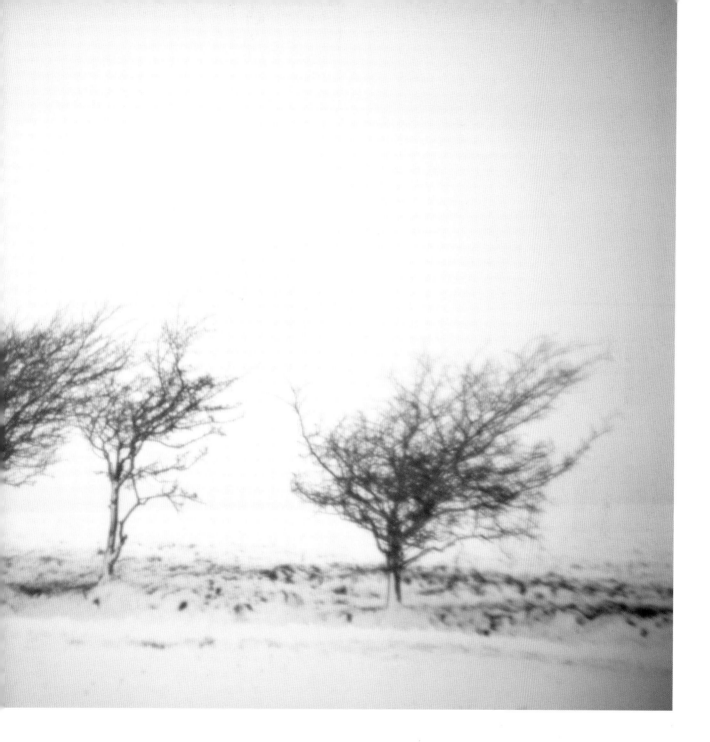

shutter speed to the reciprocal of the ISO (so ISO 100 and 1/100 sec, ISO 200 and 1/200 sec, and so on).

Regardless of how you determine the exposure for your shots it's a good idea to assess the histogram after you've taken a photograph, and adjust your settings and reshoot if necessary.

Just like an analog Holga camera, a Holga lens exhibits strong (and uneven) focus and exposure fall off toward the edges of the frame.

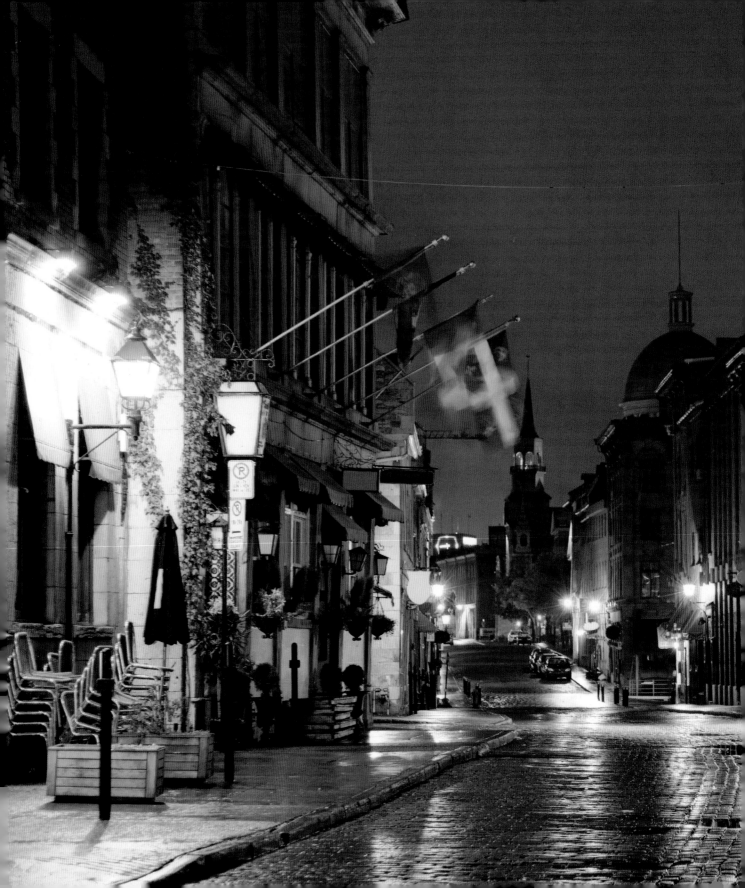

MOVIES

HD movie shooting is now almost a standard feature in digital cameras, with the majority of models allowing you to record video, as well as still images. Not only does this mean that new skills have to be learned to adapt to the subtly different process of shooting movies, but there is also a wide range of accessories and add-ons designed to make the experience easier.

These accessories exist because digital cameras are designed for still imaging first, and movies second. At a very basic level the camera is designed differently to a dedicated camcorder, and this isn't ideal for recording video, or its accompanying audio. However, the projects featured in this chapter will help you to overcome numerous shortfalls in the crossover process, from simply holding your camera, through to recording superior sound.

If you look at the design of most old-school Super 8 cine cameras they have one thing in common: a handle dropping down from the bottom of the camera so you can hold it like a pistol (hence the "pistol grip" label). Pistol grips were also used in the world of still photography—especially in the 1960s and 1970s—but fell out of favor as camera designs became more ergonomic. However, as cameras have become smaller and recording movies is now commonplace, a pistol grip is once again a useful tool when it comes to improving your camera handling. It's an accessory that doesn't need to break the bank, either.

1 If you're using a motorcycle grip, start by measuring your dowel rod against the grip and cut the wood so that it is the same length. If you're not using a grip you can simply cut a length that's roughly 5-6 inches/12.5-15cm long (or long enough to be comfortable in your hand). Sand the cut end to remove any splinters.

2 Mark the center of the wooden dowel and drill it to a depth of approximately 1/2 inch, using a drill that is slightly smaller than your 1/4-inch bolt (a 3/16-inch drill is ideal). Drill the hole as straight as possible: it will help to clamp the rod so it doesn't move as you drill it.

3 Mix up some epoxy resin and push this neatly into the hole. Then, screw your 1/4-inch bolt into the hole. As the hole is slightly undersized, this is going to be easier if you're using a soft wood (rather than a hard wood), but it will make sure that the bolt sits tightly in the hole.

1

2

3

4 Once the resin is dry, mark the top of the bolt approximately 1/4-inch above the top of the wooden dowel and saw it off so you are left with a small, threaded end exposed above the wood. A Dremel or similar cut-off tool is useful here, but a hand saw will work fine as well. File off any sharp edges, taking care not to damage the thread.

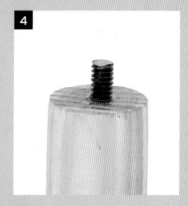

5 The next step is to glue your rubber or foam washer/disc to the top of the wooden dowel. I'm using a foam disc designed to stick to furniture feet to protect wooden floors from getting scratched—it just needed a hole making in the center.

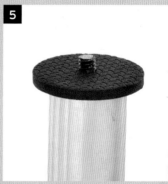

6 Finally, fit the motorcycle grip (if you are using one). You can glue this as well if you want to.

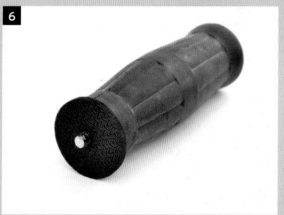

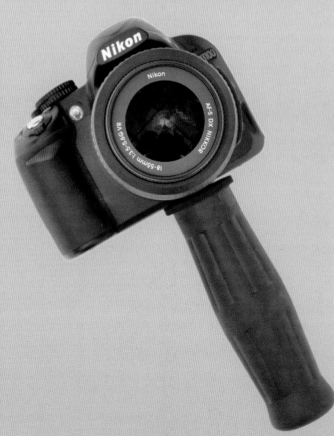

Left: The finished pistol grip fitted to a digital SLR, although it is even more useful with smaller cameras, such as CSCs and point-and-shoot compacts.

WIDE GRIP

Although digital SLR cameras and CSCs can record fantastic high-definition (HD) video, the design of these cameras really isn't conducive to shooting moving images. A pistol grip (Project 23) is a great start point if you want to handhold your camera and shoot movies (you can hold the camera in one hand and set the focus with the other), but any grip that you use single-handed with the camera held away from your body is never going to be the most stable option: there's a reason why dedicated video cameras are the shape they are.

It is possible to improve the handling of your camera though, and in this project we'll look at a simple, yet effective grip design that works on the principle that a wider grip will give you better stability.

CONSTRUCTION

In a most basic sense the wide grip is nothing more than an elongated rectangular frame that you mount your camera in. The optimum width for the frame is shoulder width, so base your pipe lengths on this. You will need one length of pipe that's approximately the width of your shoulders (in this case 50cm), and two pipes that are just under half this length (in this instance 22.5cm each). In addition, you will need two shorter pipes to act as hand grips—15cm will be about right.

The accompanying diagram (1) is fairly self-explanatory: your longest pipe is positioned at the top; the two hand grips to the sides; and the two shorter lengths at the base of the frame. These are held using right-angle connectors, with a flat-sided inspection box (or similar) placed centrally at the base of the frame to act as a camera mount.

WHAT YOU NEED
- Plastic pipe (3/4-1 inch/ 20-25mm diameter)
 - 2 x 6 inches/15cm lengths
 - 2 x 9 inches/22.5cm lengths
 - 1 x 20 inches/50cm lengths
- 4 x right-angle connectors
- 1 x Inspection box (or similar flat-sided connector)
- 1/4-20 UNC bolt (1/2 inch long) and washer
- Drill with 1/4-inch drill bit
- Glue (for pipe)
- 1/2-inch long screws (6+)

DIFFICULTY ★

TIP

The two-handed design means that you will need to have a camera assistant change the focus of the lens if necessary. Alternatively, shoot with a small aperture to maximize the depth of field and make sure that your subject remains in focus.

1

20 inches/50cm

6 inches/15cm

9 inches/22.5cm

RIGHT-ANGLE CORNER

INSPECTION BOX

NOTE

When using the wide grip, turn at your waist to track your subjects, rather than attempting to use your arms to turn the camera/ grip combo.

To create the mount, drill a 1/4-inch hole through the box (2) so that you can attach your camera using a 1/2-inch long, 1/4-20 bolt and washer (3 & 4). When the frame's not being used screw a suitable nut onto the bolt to prevent it from dropping out.

Assemble the frame, gluing the joints as you go. It's a good idea to fix the joints with short screws as well (5), just to be sure that the connectors won't pull free while you're using the grip. To finish, you could use pipe insulating foam and/or racket grip tape on the hand grips to provide slightly thicker, more comfortable handles.

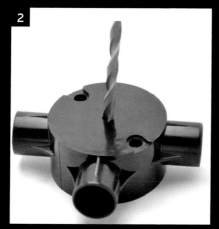

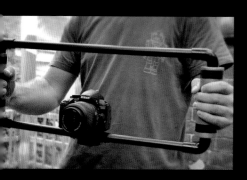

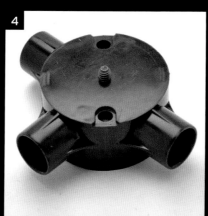

The wide grip (above) is ideal for panning shots: either to track a moving subject, or move across a sweeping vista (below).

Low-angle shots are among the most striking shots used in film making, simply because the viewpoint is so "alien." We are used to viewing the world from our natural eye-level, not from near ground level, so as soon as the camera is dropped, things naturally become more interesting and take on a (literal) new perspective.

Having the camera positioned at a low angle can also have a psychological effect, influencing the way in which a subject or scene is "read" by the viewer. For example, looking up at a person—especially with a wide-angle lens—makes them appear more powerful and dominant. In this project we're going to make a specialist grip that is perfect for filming handheld from low angles.

1. As with the wide grip (Project 24), plastic pipe is the material of choice here: it's lightweight, easy to work with, and cheap. I'm working with 20mm conduit pipe from my local hardware store, which I've cut down to the sizes given right. Note that none of the measurements provided are absolute, so feel free to lengthen or shorten the pipes to best fit your camera: I like to have the grip behind the hotshoe so accessories can be attached, but you might not need that, for example.

2. To mount the camera to the grip I've chosen to use a flat, round "inspection box" with a removable cover, but anything similar would be suitable. The advantage of this particular box is that the cover can be removed, allowing me to drill a 1/4-inch hole for the 1/4-20 bolt that will be used to attach the camera.

3. The next step is to assemble the grip based on the accompanying design: I'm effectively making a "C" shape with an extended handle at the top.

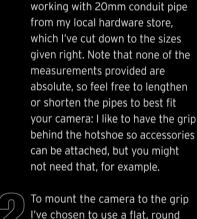
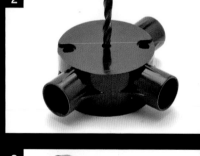
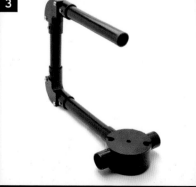

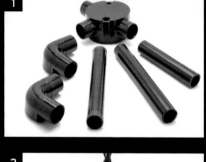
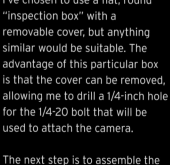

4 As the weight of the camera is going to be at the bottom of the "C" you need to make sure that your joints are secure, so use an appropriate adhesive to glue the pipes together firmly. I've also screwed through the various joints to hold the pipes in place.

5 It's now a case of attaching the camera using a 1/4-20 bolt through the hole in the inspection chamber. Once the bolt is tightened, the chamber cover can be refitted and the low-angle grip's good to go—adding a motorcycle handlebar grip gives it a pro finish and makes it more comfortable to hold.

To use your low-angle grip, simply hold the handle at a low level: you can use your arm and wrist to direct the camera, making it ideal for low-level tracking shots.

Right: Shooting from a low angle can have a significant effect on the way in which the viewer interprets a scene.

When you hold a digital SLR with your hands, the compact form and lightweight design provide plenty of opportunity for the camera to move around multiple axes, however, this also means the camera might be subject to shake, jitter, and wobble. The hand grips seen in the previous projects will help to a certain extent, and enable you to retain a degree of flexibility when it comes to changing the height and angle of your camera mid shot. However, if you're shooting from more of a fixed position, then a shoulder mount, or shoulder rig that creates a triangle between hands and shoulder, will limit the camera's freedom, and increase your control and stability.

A shoulder mount provides three points of contact and stabilization: two are held by the hands, and the last corner of the triangle is, as the name implies, the shoulder. For the hands, you will need handlebars; for the shoulder you will need a cushioned, but sturdy element with a curved profile so it wraps around the chest and shoulder; and the camera itself will need to be mounted on top.

SHOPPING

The shoulder mount requires a fairly specific mix of parts, but most of these can be found in your local hardware store. The parts fall into two categories: plumbing pipe, and metal platform/EMT clamps/screws. To start with, head to the plumbing section of the store, and find the 1/2-inch (1.27cm) diameter pipes. It's a good idea to assemble the shoulder mount skeleton inside the

store to check if all the parts are working fine and to make sure that all of your parts have the same diameter.

You will also need a metal sheet that will form a camera base, plus four EMT clamps and screws: it's important to check that the EMT clamps fit around the main pipes you'll be using for your shoulder rig, and that the screws fit into the EMT clamp holes.

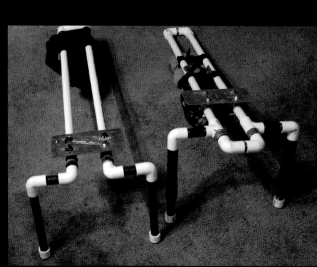

Variations on a theme: the shoulder rig we are making is on the right, with a lighter (but less stable) version to the left.

DIFFICULTY

ASSEMBLY

Although the list of materials is relatively extensive (not to mention quite specific), assembling your shoulder rig should be fairly straightforward: the accompanying diagram (1) will give you an idea of the shape you are looking to create.

Start by screwing the various lengths of pipe into the relevant connectors, and then stick the two main pipes/rails into the T-connectors. Push them in really, really hard, otherwise their connection might loosen over time, and glue these joints as well.

Next, take your metal platform and use your drill (and 1/4-inch drill bit) to drill five holes into the platform. Four of them should be positioned directly above the top holes of the EMT clamps, with one additional hole at dead center, which is where you will mount your camera.

Insert four screws into the top holes of the EMT clamps and fit them around the two main pipes. Tighten the screws with nuts, put the platform on top so it slides down on the screws, and lock the screws with a second set of nuts on top of the platform (2). If everything went well and the screws are short enough, they won't stick out of the nuts, see picture.

Slide the platform to the desired position on your main rails, and use the remaining screws to tighten the EMT clamps (3).

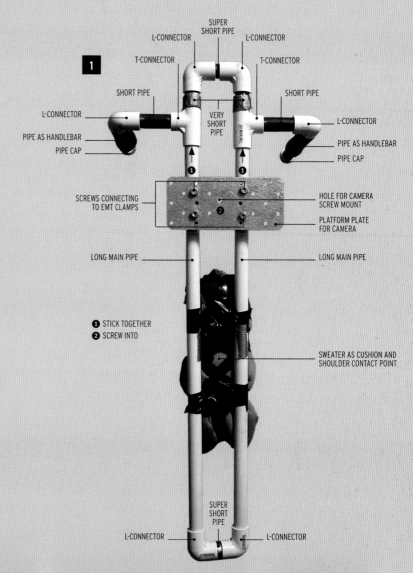

1

SUPER SHORT PIPE
L-CONNECTOR
L-CONNECTOR
T-CONNECTOR
T-CONNECTOR
SHORT PIPE
SHORT PIPE
L-CONNECTOR
VERY SHORT PIPE
L-CONNECTOR
PIPE AS HANDLEBAR
PIPE AS HANDLEBAR
PIPE CAP
PIPE CAP
SCREWS CONNECTING TO EMT CLAMPS
HOLE FOR CAMERA SCREW MOUNT
PLATFORM PLATE FOR CAMERA
LONG MAIN PIPE
LONG MAIN PIPE

❶ STICK TOGETHER
❷ SCREW INTO

SWEATER AS CUSHION AND SHOULDER CONTACT POINT

SUPER SHORT PIPE
L-CONNECTOR
L-CONNECTOR

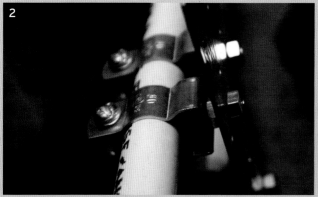

2

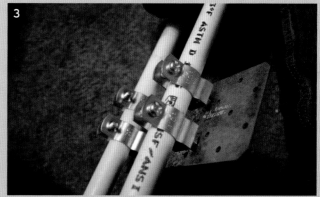

3

SHOULDER PIECE & HANDGRIPS

To help cushion your shoulder from the weight of your camera, take an old sweater or towel and roll it into a tight, flattened sausage. Use electrical tape to bind it, so that it stays in shape.

Start taping the sweater sausage to the back of the two main rails. In my case, I used a second sweater as a block (the brown one, as seen in the accompanying illustration) to increase the curvature of the shoulder piece. After taping your shoulder pad lightly to the rails, shape it so that it creates a curved profile that wraps around the shoulder and chest area, and hold this shape with tape. Finish it off with a lot of tape so the sweater won't move (4), or lose its shape.

To soften the handlebar grips, use paper towels (5). Tape a bit of paper towel onto the bars and then roll the remaining sheets around tightly until the bars feel puffy. Wind tape around them so you cover the paper towels and get a softer grip. You could use sports racket tape and achieve a similar look.

Finally, attach your camera using the 1/4-20 thumbscrew (6) through the central hole of the camera platform and you're good to go: just sit the mount on your shoulder as you shoot.

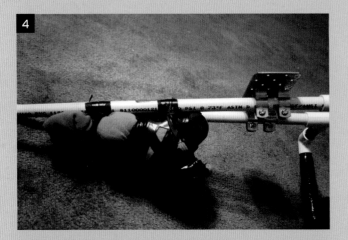

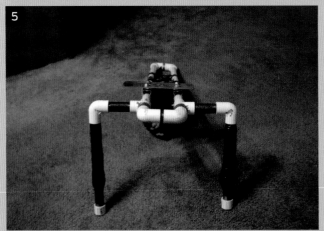

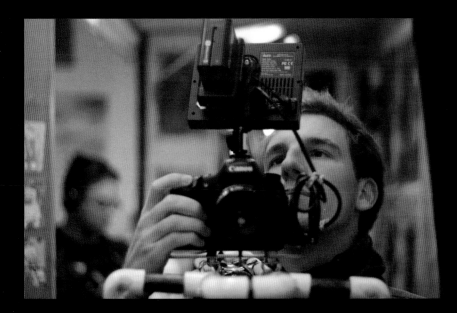

Left: The shoulder mount in use, supporting both a Canon EOS 7D, as well as an external monitor.

Below: It may only be made of humble plumber's pipe, but the shoulder mount has a distinctly professional stance.

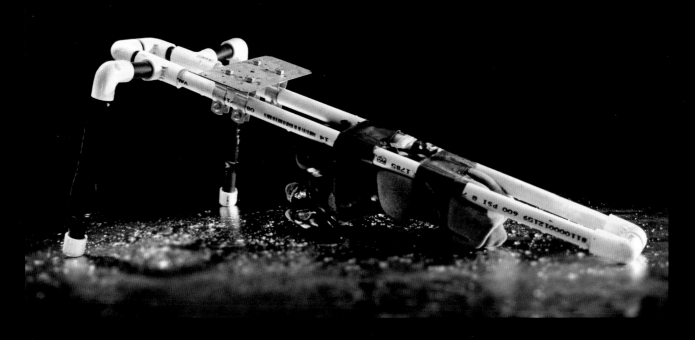

TABLE DOLLY

Movie makers often use dollies to produce super-smooth tracking shots. There are dozens of different designs that are available commercially, ranging from wheels that attach to a standard lightstand (or tripod), through to the rail systems used on big budget shoots. However, if you only shoot movies occasionally, you might not want to invest in a commercial solution, in which case this micro camera dolly could be ideal.

Made from ultra low-cost PVC pipe, the dolly allows smooth tracking shots to be made from any flat surface, such as a tabletop, and the adjustable axles enable you to track in a straight line or follow a curve. The small size is also ideal for traveling, and the pieces can be easily separated for quick storage.

WHAT YOU NEED
- 5 x 3/4-inch PVC slip plugs
- 3 x 3/4-inch PVC tee joints
- 2 x 3/4-inch PVC 90 degree elbow joints
- 4 x 3/4-inch PVC pipes, 1 x 1/2-inch long
- 4 x 3/4-inch bolts, 2-inch long
- 1 x 1/4-inch bolt, 1/2-inch long
- 8 x 1/4-inch nuts
- 5 x 1/4-inch lock washers
- 1 x 1/4-inch rubber fender washer
- Drill with 1/2-inch drill bit
- Socket wrench with long 7/16-inch socket
- Pliers
- 7/16-inch wrench

DIFFICULTY ★

1 Before you begin, drill a 1/4-inch hole into your five PVC plugs. Then, take one of your 2" long bolts and drop it into one of your inline skate wheels: it should slide straight through.

2 Add a 1/4-inch nut to the threaded side of the bolt and tighten it down by hand.

3 Slide one of your PVC plugs over the bolt, so the flat side of the plug is resting against the nut.

4 Next slip a lock washer over the bolt thread.

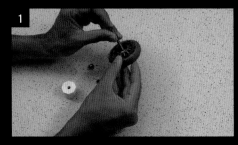

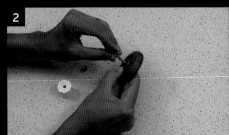

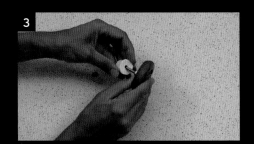

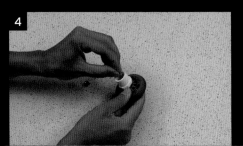

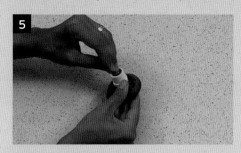

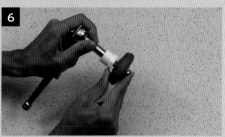

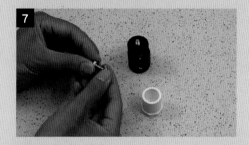

5 Then attach another 1/4-inch nut.

6 Using your two wrenches, tighten the nut until the lock washer collapses. Check that the wheel spins: if it is too tight, loosen the nut slightly. Repeat steps 1–6 for the other three skate wheels.

7 With your wheels assembled you can turn to the camera mount. Start by adding a lock washer to your 1/2-inch long bolt.

8 Push the bolt and washer through the bottom of your last PVC plug, so that the threads emerge on flat side of the plug.

9 Attach your mini ball-head to the exposed threads and tighten using your socket wrench.

10 To assemble the dolly's wheels push one of your completed wheel assemblies into one side of a tee joint: the plug cap should sit firmly in the tee.

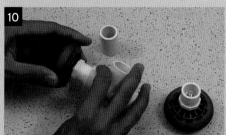

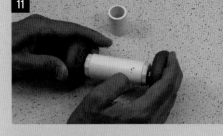

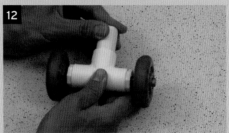

11 Push a second wheel into the opposite side of the tee.

12 Push one of your 1 1/2-inch lengths of pipe into the top of the tee. Repeat steps 10-12 to make the second set of wheels.

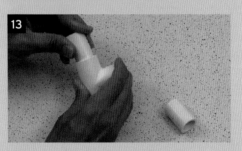

13 To make the dolly's chassis, insert a short length of pipe into the remaining tee joint.

14 Insert a second length of pipe into the opposite side of the tee joint.

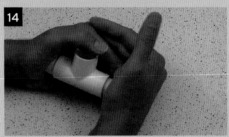

15 Attach 90-degree angles to both of the pipes you just inserted into the tee joint.

16 Then fix one of your finished wheel assemblies to one of the angled elbows.

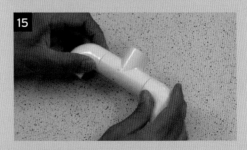

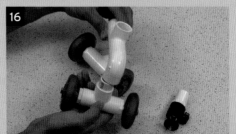

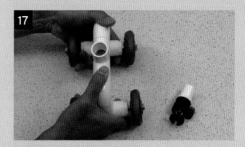

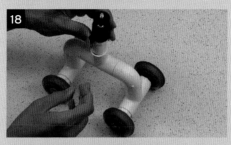

17 Next, add your second set of wheels to the second elbow joint.

18 Finally, slot the ball head assembly into the top of the upper tee joint.

19 As an optional step, you could add a quick-release adapter to your mini ball head so that it is quicker to attach and remove your camera (or swap cameras).

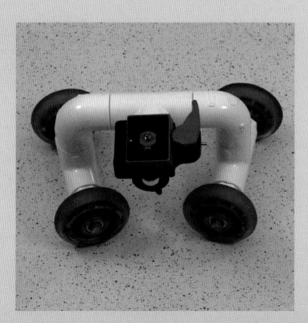

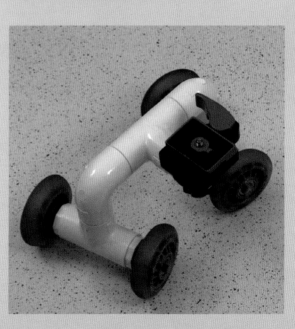

Above and Right: Because the joints aren't glued, the finished dolly is fully articulated, allowing you to turn the wheels so you can move the camera in an arc as well as setting it straight for smooth tracking shots toward or away from your subject. You can also turn the upper tee joint on its side (as shown) for lower-angle shots.

If you have ever wanted to shoot movies directly from your bicycle, then this project is for you. You may already have many of the parts you need, but even if you haven't got everything you need in your workshop or shed, you can probably get all of these things at a local hardware store—a local bike repair shop may even give you a reflector for free. If not, the total cost is still going to be less than $5 (£3), for which you can make a sturdy handlebar mount for any camera with a standard 1/4-20 tripod thread. This camera mount will also work if you want to film slow dolly shots on even terrain: simply walk the bike around your subject.

WHAT YOU NEED
- Bicycle reflector
- 1 x 1/4-20 thumb screw (1 1/2-inch long)
- 3 x 1/4-20 nuts
- 2 x 1/4-1 inch washers
- 1 x 1/4-1 1/4 inch washer
- 1 x 1/4-1 1/4 inch rubber washer
- 1 x 1/4-20 cap nut (dome nut)
- 1 x bike reflector
- Drill with 1/4-inch drill bit

DIFFICULTY ★

1 The most common type of bicycle reflector—and the type you need for this project—has a screw that clamps the reflector to your bike, and another that allows the reflector to swivel. Start by removing the screw that allows it to swivel and the reflector itself.

Drill the hole that's left in the clamp out to 1/4 inch. You may find there is a small metal nut in the hole, which normally retains the swivel screw, but this should push out easily with the drill.

2 Next, twist three nuts onto the thumb screw. A nylon spacer could be used in their place if you have something suitable. The nuts (or spacer) will prevent the thumb screw from hitting the reflector clamp when it is turned.

Slide the clamp onto the thumb screw, followed by the two small washers; the larger washer; and finally the rubber washer, as shown in the accompanying shot.

1A

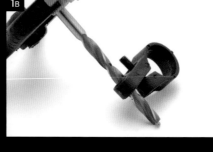

1B

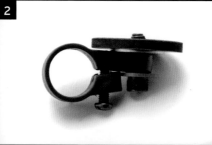

2

WARNING

The faster you're traveling, the higher the risk is to your equipment if a stone or other debris is flicked up from the road or pavement. Even a clear UV or skylight filter over your lens isn't going to save your camera if a stone impacts at high velocity.

NOTE

As well as using your bike mount to shoot movies, you can also use it to record timelapse sequences of still images. This will work best with a camera that has a built-in intervalometer that allows you to shoot a specific number of images with a fixed amount of time between them—that way you don't need to take your hand off the handlebars to take a shot. Instead of viewing the resulting images individually, combine them in your movie-editing software to create a high-speed, animated movie of your bike journey.

3 Attach a cap nut (also known as an acorn nut or dome nut) to the top of the thumb screw to hold the washers in place. Then, loosen the clamp screw and fit the reflector clamp onto the handlebars of your bicycle. Tighten it down, but note that you may need to add a rubber spacer between the clamp and the bars to make sure it's a good fit, depending on your tube size.

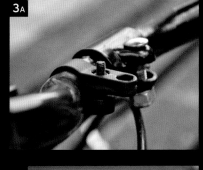

3A

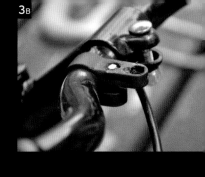

3B

4 Once fitted, remove the cap nut and attach your camera to the thumb screw. Make sure it is secure, but do not overtighten the thumb screw. Tie the camera strap to the handlebars for added security and you're good to go!

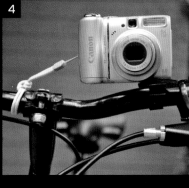

4

Below: Your bike mount can be used to shoot a wide range of movies and stills, from fast and frenetic action to eerily quiet streets at night.

MICROPHONE SHOCK MOUNT

If your camera records HD video, then it will have a built-in microphone to record audio as well. However, built-in mics are pretty useless in most situations—unless you're shooting in an otherwise silent environment people's voices can get lost to background noise and even the various sounds your camera makes as it focuses. This makes an external microphone almost essential, and when you want to record dialog it's hard to beat a "shotgun" mic. This is often used on a boom arm and held over the subject, as close as possible without appearing in shot, so that the cleanest audio is recorded.

The problem is, a microphone cannot discriminate between wanted and unwanted audio. A common mistake is to just mount a mic on the end of a boom pole, but any movement by the boom operator (such as sliding his or her hands along the pole) will be transmitted directly to the microphone, potentially ruining the audio recording. A better solution is to suspend the microphone away from offending sound conductors, using what is known as a shock mount to isolate the mic. A shock mount is designed to minimize vibrations that may result in unwanted sound interfering with your recording, which means that your sound quality will be optimized.

WHAT YOU NEED
- 1 1/4 x 1/2-inch PVC tee
- 4 x large rubber bands or hair bands
- 1/2-inch PVC pipe (3-4 inch in length)
- Rotary tool (or similar)

DIFFICULTY ☆

Below: Commercial shock mounts can be expensive, especially if you only use your camera for movie recording occasionally.

1 Place rubber bands on your PVC tee as shown. They should criss-cross at either end of the tee, leaving a hole in the center that is slightly smaller than the diameter of your mic: the microphone should fit snugly into the hole.

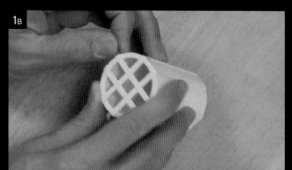

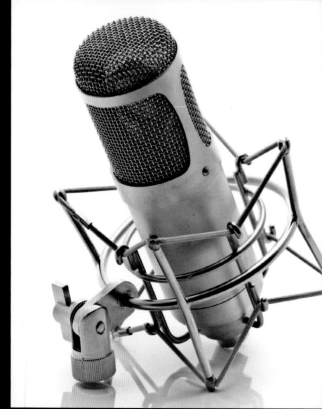

2 When your bands are fitted mark their position at either end of the tee, drawing a line along both sides of each band. When you've marked the location of each band, remove the rubber bands.

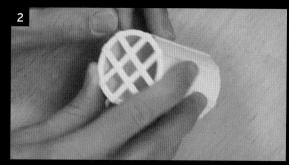

3 Using your rotary tool and a router bit, make a small notch between each pencil mark. When you have made notches for all of your rubber bands, at both ends of the tee, replace the rubber bands, positioning them so they sit inside the newly cut grooves.

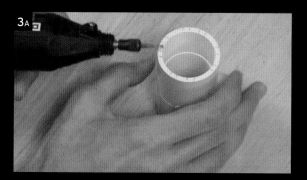

3A

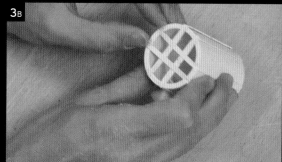

3B

4 Finally, insert your 1/2-inch diameter PVC pipe into the shock mount to form a short handle that you could handhold, attach to a shoulder rig (see Project 26), or as we will see in the following project, fix to a boom arm to create a versatile off-camera sound recording solution. All you need to do now is to slide your mic into the mount and any vibration caused by handling the mic will be reduced.

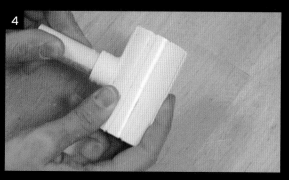

4

Left: The finished shock mount with a microphone fitted. This mount has been wrapped in fabric sports tape (the type used on racket handles) to give it a more "professional" look.

There are countless variations when it comes to DIY microphone boom poles, but most of them usually involve modifying a painter's extension pole for this purpose. This will work perfectly well, but has one drawback—you need to take the whole pole with you whenever you think you might need it.

This project shows you how to create a compact boom arm adapter that's perfect if you're traveling, as it will allow you to use any available pole with painter's pole-type threads as a boom arm. This means you don't necessarily need to take a pole with you—you simply need access to one when you want to shoot (they're available from all hardware stores, so not hard to track down). The adapter also enables you to tilt the microphone for optimum mic placement, which is often overlooked in homemade pole designs.

WHAT YOU NEED
- Paint roller
- Microphone clip
- 5/8-inch to 3/8-inch thread adapter for microphone clip
- 3/8 inch threaded rod (3-4 inches long)
- Drill with 5/16-inch drill bit
- PVC cutters (or similar pipe cutting tool)
- 2 x 3/8-inch nuts
- 2 x pairs of pliers

DIFFICULTY ✶

NOTES

Microphone clips can be found on the top of broken (and functioning!) mic stands, or can be bought on their own. It is this clip that allows you to tilt the mic so that it is in the best position for your requirements.

A boom adapter can be used on its own (without a painter's pole) as a pistol grip mic mount.

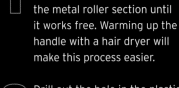

1 Remove the paint roller from the plastic handle by turning the metal roller section until it works free. Warming up the handle with a hair dryer will make this process easier.

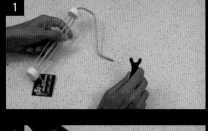

2 Drill out the hole in the plastic handle with a 5/16-inch drill bit.

3 Take your microphone clip and add a 5/8 inch to 3/8 inch thread adapter, making sure to screw it securely into place.

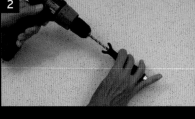

4 With the thread adapter fitted, screw your 3/8-inch threaded rod into the microphone clip.

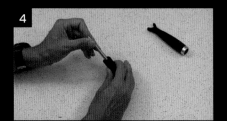

5 Returning to your paint roller handle, chop off the handle at the narrowest point on the neck using PVC cutters (or similar).

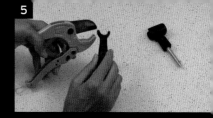

6 Take the microphone clip and screw the exposed threaded rod into the roller handle. As the threaded rod is slightly larger than the hole you drilled in the handle, it should sit snug in the handle as you screw it in.

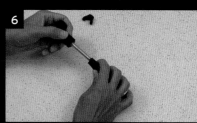

7 Once the threaded rod is seated in the roller handle, remove the mic clip and attach two 3/8-inch nuts to the top of the threaded rod. Turn them against each other using two sets of pliers until they are tight.

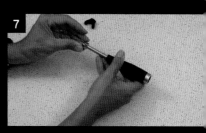

8 With one hand, attach a pair of pliers to the nuts. With the other hand, hold the handle firmly and turn the threaded rod so that it is screwed into the handle. Continue screwing it in until the nuts reach the top of the handle: this may take a while!

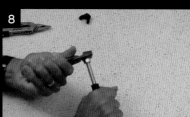

9 Unscrew both nuts and remove them from the threaded rod before re-attaching the microphone clip. Your microphone adapter is now ready to use: either attach it to a painter's pole to create a boom arm, or use it on its own as a handheld pistol grip.

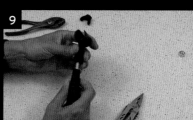

Left: The boom adapter is shown here fitted to a painter's pole. In conjunction with the microphone shock mount from the previous project you will have a pair of accessories that will help you to record the best possible audio for your movies.

If you're looking to design a great title sequence for your movie, but have zero budget, then this project will show you how to create cool, smokelike effects using nothing more exotic than milk. The entire project can be done for free (unless you have no milk at home), and the effect can be combined with text in After Effects or another video-editing program, ready to be used as a title animation.

It might be the enzymes in the milk, or the genetic manipulation of cow food, or perhaps the motherly aspect of cow milk, but for whatever reason the effect that is unique is little particles that drag a white tail behind them, creating interesting movement and behavior. You can try throwing other kinds of liquids in a jar of water—oil, juice, sauces, powder dissolved in water, and so on—but guaranteed they all suck in comparison to milk!

1 THE SETUP

Position your black backdrop against a wall (or lightstand) and the counter/table. Make sure everything is quite flat.

2

Fill your glass container with water and put it onto the black background. As you will be refilling it many times, it's a good idea to mark its position so you don't have to refocus your camera every time you move it.

3

Set up your camera in portrait (upright) orientation, close to the glass container. Zoom in so the container is bigger than the frame and you can't see the edges of your water container.

4

Position two LED lights above the container, pointing downward. They will disperse light into the water and nowhere else: the glass has to be "invisible," which you mainly achieve by zooming in and hiding the edges. You can use any light source, but LED flashlights work particularly well.

WHAT YOU NEED
- Camera
- Tripod
- Clear glass container (jar, fish tank, glass) that doesn't distort its contents too much visually, and has no visible scratches/stains
- Glass of milk (you will use minimal amounts)
- Water (it's a good idea to work close to a tap)
- A straw/empty pen shell or similar
- Black drape (paper, fabric, or anything black/dark and not too shiny)
- Lights (two strong LED flashlights from a 99 cent store will do)

DIFFICULTY ★ ★

TIPS

Experiment with a variety of fluids, lighting setups, lighting angles, and playback/recording speeds: adjusting any one of these can create an entirely different look.

Stirring the water in the glass to create a vortex will draw the milk toward the center.

If you have time, try the same process with a white background and ink to add color to the credits.

① 2 FLASHLIGHTS	⑤ CAMERA (SIDEWAYS, ROLLING)
② STRAW	⑥ WATER CANISTER
③ MILK	⑦ MILK DROPLET
④ TRIPOD	

The milk effect is a quick, cheap, and very effective way of creating unique backgrounds for your movie title sequences.

1 SHOOTING

With your stage set, it's time to shoot. It's important to note that small milk drops will have a significant effect, so we have to find a way to disperse very small amounts of milk into the clear water. Use a straw/empty pipe and dip it a little into the milk glass. Close the pipe's top end with your finger to trap the milk inside the pipe (thank you physics!) until you let go. By only releasing your finger a little you can control the size of droplets you let fall into the glass.

2

Position your hand with the straw above your container of water and press Record on your camera. Relax, and let a milk droplet go. You will be able to follow the milk's movement, evolving from thin streamers to the whole glass becoming milky.

3

Once the water is milky it is useless, so stop recording, empty the glass container, and rinse out any remaining residue. Refill the container and repeat the process multiple times until you have a wide range of "drop shots" to choose from. In your editing program you can choose the take that is most effective and use that one for your credit sequence.

LIGHTING

Photography is all about light (the very word itself derives from "light painting"), and it would be impossible to take any pictures without it. However, simply having light isn't enough: if you want to produce the best shots, the quality and direction of the light is paramount. For this reason, photographers working in a studio will have myriad accessories that they can attach to their strobes: softboxes to soften the light, snoots to direct it, reflectors to bounce it back onto their subject, and countless options in between. This provides them with absolute control over the outcome of their image, but it doesn't come cheap—a full studio setup could easily run into tens of thousands of dollars. However, controlling light doesn't have to be expensive, as you will discover in this next chapter.

Of all the possible light sources you can use for photography, the cheapest—and, arguably, easiest to use—is sunlight, or at the very least "daylight" if the sun is hidden behind cloud. With the right tools it's possible to create a virtual studio outdoors, using natural light to illuminate your subject. The key tools are reflectors (sheets of white, silver, and/or gold card are ideal), but on especially bright days a diffuser can be equally beneficial, enabling you to soften the light falling onto your subject and avoid deep, hard shadows. Although diffusers are available commercially, in this project you'll see just how easy it is to construct a lightweight, portable diffuser that can double as a reflector. All sizes can be modified depending on your requirements.

1 The maximum size of your diffuser will be dictated by the size of the shower curtain you are using: the curtain I'm using here measures 180 x 180cm, so that would be my maximum possible diffuser size. However, as the pipe I've chosen comes in 300cm lengths, I've decided to make my diffuser rectangular and slightly smaller (roughly 60 x 40 inches/150 x 100cm) so I'll only need to use two pipes. The basic design is shown in the accompanying schematic (1).

2 With a rough plan in mind, the first step is to cut the pipe to size. My diffuser calls for three 40 inches/100cm lengths, plus four 30 inches/75cm lengths. A hand saw is more than capable of cutting through the pipe, but you may need to sand or file any rough edges. Alternatively, you can use dedicated plastic pipe cutters, although they are more expensive.

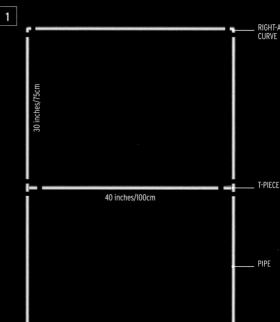

1

RIGHT-ANGLE CURVE

30 inches/75cm

T-PIECE

40 inches/100cm

PIPE

2

3 With your pipe cut to size, assemble the frame using the right-angle corner pieces and T-pieces. You can glue the joints if you want to construct a permanent frame, or tape them so you can dismantle the diffuser between shoots. A compromise is to glue the corners and T-pieces to create two long, permanent sides, and then tape the cross pieces so your diffuser will pack down for transporting, but require minimal assembly and disassembly.

4 When you've made your frame you need to attach your diffusion material. I'm using adhesive hook and loop fastener material for this, sticking a tab to each of the corners of the frame, as well as the top of the T-pieces. This will be adequate for calm conditions, but may pull free in a breeze, so you might want to use longer strips along your pipes as well.

5 Peel the backing paper off your hook and loop fasteners and lay your shower curtain over the top of your frame. It doesn't have to be stretched tight, but you don't want it to sag either. Press down to stick the diffuser to the hook and loop.

6 If necessary, trim your diffusion material to size and you're good to go. To use the diffuser, simply have an assistant hold it between your subject and the sun to minimize the intensity of the shadows, and/or close to your subject when you want to use it as a reflector. When you're finished, you can remove the diffuser material and collapse your frame.

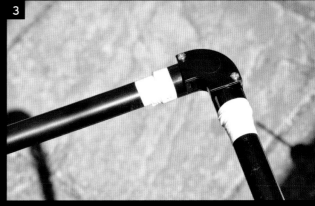

3

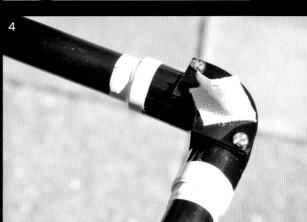

4

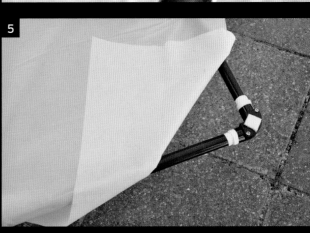

5

6

Photographing close-up subjects outdoors is never easy. For a start, you will often find yourself dealing with a shallow depth of field, even with the smallest aperture setting on your lens. This can be overcome using focus stacking techniques (see Project 12), but this won't help with another common problem: harsh, contrasty lighting. This can be especially problematic with delicate subjects such as flowers, where a softer light would be preferable. To a certain extent reflectors can be positioned to bounce the ambient light and lighten shadows, but it can be awkward to use more than one reflector and operate your camera at the same time. However, as you will see in this project, there is a simple solution: a portable location light tent. It can also come in handy for studio shots as well!

1 Start by taking one of your 20 inch/50cm lengths of pipe and attaching a T-connector to each end as shown in the accompanying illustration. For this project, taping the joints with electrical tape is preferable to gluing them, as it will enable you to dismantle the light tent when you're finished.

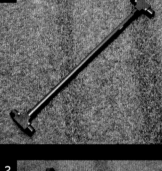

2 Fit a 10 inch/25cm length of pipe to each end of the T-connectors to create an "H" shape, and then attach a right-angle joint to the end of each of the shorter pipes, making sure to point the connector downward.

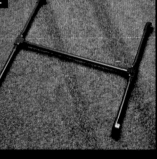

3 Fit your final four 20 inches/ 50cm lengths of pipe to the downward-pointing connectors to create "legs" for your light tent frame, which will now be fully self-supporting.

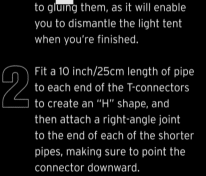
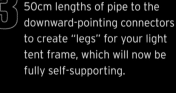
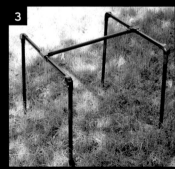

TIP

It's a good idea to tape around the slit you cut in the front diffuser panel. Use electrical tape on both sides of the diffusion material to prevent it from splitting further.

NOTE

If you want your frame to be more rigid once it has been assembled, tape the joints after step 3. Doing this will hopefully stop the "legs" from rotating inside the connectors.

4 To make the diffusion material for your frame, measure the top, sides, and back of the frame and cut pieces from your shower curtain to match these dimensions. Use small squares of adhesive hook and loop fastener to attach the diffusion material to the frame—a small square in each corner of the diffuser panel should suffice.

5 For the front diffusion panel, cut a piece of shower curtain to match the dimensions of the frame, but cut a slit in the center that will allow you to poke your camera lens through.

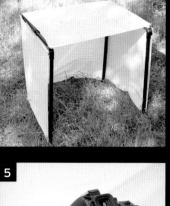

To use your light tent, simply place it over your subject and attach as many (or few) of the diffusion panels as you want. Remember that as well as acting as a diffuser to soften harsh lighting, the panels will also reflect light, so can be used on either side of your subject. They can be employed to create a "seamless" white background for outdoor subjects, or to act as a "windbreak," to prevent a breeze from creating subject movement

Below: On a bright day, direct sunlight can create harsh shadows. A light tent can quickly overcome this, diffusing the light to illuminate your subject more evenly.

On-camera flash is something of a paradox, with its positive traits balanced by negative aspects. For example, the built-in flash on most cameras is great when it comes to shooting in low-light conditions, but the low power means that subjects have to be close and/or wide apertures used if you want to get a good exposure without resorting to slow-sync flash. Similarly, as a fill light on a bright day your camera's built-in flash is often adequate, but use it as the primary light source and it will produce hard, unflattering shadows. Its close proximity to the lens is also likely to result in red eye, so it's not ideal for portraits.

However, it's incredibly easy to modify the output of a "pop-up" flash, and there are countless light-softening solutions. In this project we're going to make an ultra-simple diffuser for a pop-up flash that will take the edge off your hard shadows by scattering the light. The irony is that you need a translucent film canister to make this happen on your digital camera, so start by asking your local processing lab for a couple of canisters if you don't have them already—most labs will be happy to oblige.

WHAT YOU NEED
- Camera with "pop-up" style flash
- Translucent film canister
- Ruler
- Craft knife

DIFFICULTY ★

NOTES

Depending on your camera model, the diffuser may cause your flash exposures to come out slightly underexposed, so be prepared to dial in positive flash exposure compensation to increase the flash output.

Be aware that the diffuser may affect the color of your images. This can have a positive effect —if the diffuser warms the flash, it can make skin tones in portraits appear more pleasing, for example—but if you'd prefer neutral results you might need to create a custom white balance.

1 With your translucent canister to hand, measure the height of your camera's built-in flash so you know what size to make your diffuser. To do this, "pop up" your camera's flash and hold a ruler in front of it, making a note of the measurement.

2 Mark two parallel lines running from top to bottom on your empty film canister. These should be slightly closer together than the measurement you took for the height of your flash, so if your camera's flash is 10mm high, space your lines 9mm apart. The reason for this is simple—it will be far easier to make the gap wider if needed, but much harder to make it smaller.

3 Cut carefully along the two lines with your craft knife and then across to make a rectangular slot in the film canister. Be sure not to cut all of the way to the ends of the canister.

4 You should now be able to push the canister onto your camera's built-in flash and it will hold by itself. If it's a bit tight, make the slot a little larger and try again. Keep the film canister's lid on to give the diffuser added rigidity and make it look more "finished": use clear sticky tape to hold the lid on if necessary.

In the previous project you saw how easy it is to make a fantastically robust, go-anywhere flash diffuser that will help soften the light from your camera's pop-up flash for less intense results. In this project we're going to take that idea a step further, and combine direct, diffused light with soft bounced light. In essence, what we're doing here is "splitting" the light from the camera's built-in flash, so some of it is sent directly toward the subject, and some of it is bounced upward to reflect off the ceiling and create a nice gentle fill.

WHAT YOU NEED

- Cereal box card (or similar thin card)
- Aluminum foil (optional)
- Translucent plastic milk carton
- Ruler
- Craft knife
- Sticky tape

DIFFICULTY ★

1 Start by measuring the approximate width of your pop-up flash and then the distance from the back of the hotshoe to somewhere just in front of the flash. These measurements don't need to be ultra-precise, just "close."

2 Transfer these measurements to your card stock, using the accompanying template as a guide. The bounce-diffuser box can be made out of a single piece of card stock. Cereal box packaging is ideal, but anything of a similar weight will work just as well. The precise measurements are going to vary depending on your camera, but a piece of card that's roughly 12 x 8 inches (A4) should be enough to do the job.

1A

1B

2

A = width of flash
B = hotshoe to front of flash
C = B x 2
D = 0.7 inch (18mm)

3 Cut out your card template and score the fold lines. At this stage you could cover what will become the inside of the card with aluminum foil using double-sided tape or glue. This is optional, but will guarantee that the light coming from your bounce-diffuser is optimized. However, do not put foil over the bottom tab or, if you do, cover it over with electrical tape.

4 Fold both of the sides and the tab at the bottom inward, so they all point in the same direction. Measure the long, diagonal edge of the bounce diffuser and use this figure to cut a rectangle out of your plastic milk bottle: the rectangle should be the same length as the long edge of the diffuser x the width of the flash.

5 Use clear sticky tape to attach the plastic rectangle to the long edge at the front of your bounce-diffuser. Trim any edges that are slightly misaligned and you're ready to shoot: just slide the tab into your camera's hotshoe to hold the bounce-diffuser in place and sit the unit on top of your camera.

3A

3B

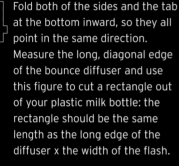

4A

4B

5

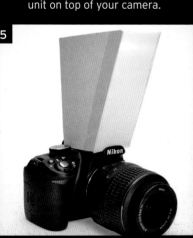

DIRECT FLASH

WITH BOUNCE DIFFUSER

As these comparison shots demonstrate, the bounce diffuser has a distinct effect on the flash: the shadows are significantly softer when the diffuser is used, especially to the left of the shot. The diffuser also adds a pleasant warmth that would be ideal for portraits, or could be corrected with a custom white balance or when converting Raw files.

36 FLASH STAND

Getting your flash away from the camera is a surefire way of improving your shots and with an increasing number of dedicated "hotshoe" flash units allowing you to control them wirelessly, this has never been easier. Even flashes that don't offer full TTL wireless control can be triggered remotely using an optical slave unit or remote trigger system, allowing you to "chimp" your exposures to get the creative results you're after. Of course, unless you have an assistant to hold each flash you want to use away from the camera, you're going to need stands of some description, such as this versatile, low-cost pipe-based flash holder.

1 Start by taking three of your T-connectors and six 8 inch/20cm lengths of pipe and assembling them to create an "H" shape as shown. With the H lying flat on your workbench (or table/floor) the central T-joint should point directly upward at a right angle.

2 Drill small holes through each of the joints (and the pipe inside) and fit screws to prevent the various pipes from twisting. Countersink the screw heads and tape over them for a more "finished" look. Alternatively, you could use a suitable pipe adhesive to hold your joints in place if preferable.

3 Take your H shape and fit one or more of your 12 inch/30cm and 24 inch/60cm lengths (and straight connectors) into the upward-facing T to make the central "pole" of your stand. You can use as many or as few pipe sections as you want, and use different lengths to make the stand as high (or low) as you want.

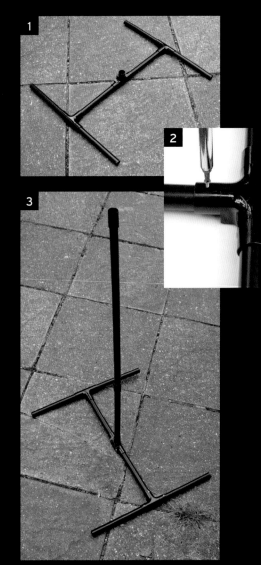

NOTE
"Chimping" an exposure simply means guessing the start exposure and then using your camera's playback histogram to assess the image and fine-tune the aperture, shutter speed, and ISO (and flash distance/power) to get the shot you want.

TIPS
If you're concerned that your lightstand might get knocked over accidentally, weigh it down by placing your camera bag (or something of a similar weight) on the H-shaped base.

The dimensions of the H-shaped base and the upright pipe sections can all be varied to suit your needs: a selection of upright pipe lengths and connectors can create a very versatile lightstand.

The final step is to make your flash mount. If the pipe you're using allows you to fit an end cap, this is ideal, but an end cap wasn't available for the conduit pipe I'm using, so I've used a T-connector instead. Regardless of the connector you use, the principle is the same: drill a hole through the cap/long edge of the T so that you can bolt your accessory shoe onto it to create your flash mount. Then, simply slot your flash mount onto the top of your stand's center pole and fit your flash.

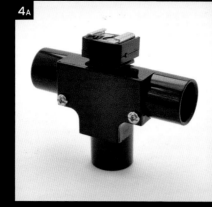
4A

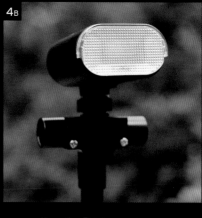
4B

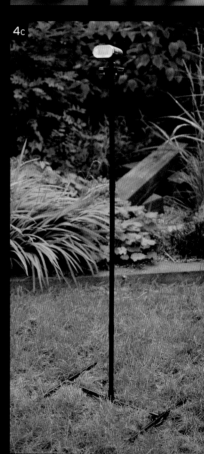
4C

Left: Moving your flash off-camera allows you to experiment with a wide range of lighting setups, which is especially useful for portraits.

Most photographers will have seen shots taken using a ringflash, whether it's in the context of high-end fashion and portraiture, or the macro world of insects and flowers. Until recently ringflash has largely been the preserve of professional photographers and monied enthusiasts, as even the most modest battery powered unit can be fairly expensive. However, recent developments in lighting (and the inclusion of HD video modes in most cameras) has meant that the manufacturers have turned their gaze toward continuous light sources; most notably, LEDs.

As a result, there is now a wide range of LED lights available, which includes an array of continuous ringlights. Yet although they are generally cheaper than their flash counterparts, LED ringlights still command a relatively premium price, especially when you consider their often basic configuration. However, as you will see in this project, making your own high-power custom ringlight isn't expensive, and it's not overly complicated either—as long as you employ a bit of common sense!

The start point here is a circular LED camping light, which can be found online or in most camping stores. Look for one that has a hole in the center, and plenty of LEDs around the edge: the light I'm using here contains 48 LEDs in two rings around the outside of the large plastic shell. Perfect!

1

The first thing you need to do is junk the on/off switch. Before you do, look at the wiring: getting rid of the built-in switch, means you'll need to rewire the lamp later on. You need to identify which wires lead to the positive battery terminal(s) and which lead to the negative terminal(s). Each ring of LEDs has two "tracks"—the inner track carries the positive current, and the outer track carries the negative current. So I remember this I've marked the negative wires with marker pen before cutting them as close to the on/off switch or battery terminal as possible.

2A

2B

3 Remove the on/off switch assembly and the metal battery terminals: you're not going to use them, and they'll only get in the way at the next stage. I've also removed a couple of additional positive wires, so I'm left with just one negative and one positive wire for each ring of LEDs.

4 Now the fun part begins. Take your filter ring and place it centrally on the outside of the LED lamp's front cover. You don't have to be precise, but it should be relatively easy to get it close to central. Then, draw around the inside of the filter ring. Repeat the process on the back casing.

5 Reach for your Dremel (or similar cutting tool) and cut out both of the circles you have drawn. If you don't have a Dremel, another option would be to use a drill with a 1/4-1/2 inch drill bit and drill lots of holes around your circle to get off as much material as possible. Then you can try using a small hobby saw or other cut-off tool to complete cutting the rough outline. Regardless of the tool you use, once the holes are made use a small sanding drum attachment on your Dremel (or some sandpaper) to tidy up the edges. Don't go too crazy with the sanding though, or you might take away too much of the plastic.

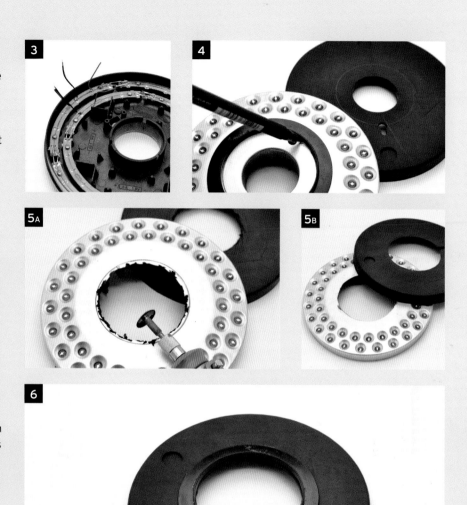

6 Once your holes are cut and tidied, take your filter holder adapter and glue it to the back cover of your LED light, making sure it is as central as possible. A hot glue gun or epoxy resin will do the job here.

7 You're now ready to wire up your light, but before you do, you need to make a hole for your wires to pass through. Roughly assemble the ringlight and attach it to a lens. Mark a point somewhere toward the top of the ring and drill a hole through the back of the ringlight as illustrated.

8 Next, take your battery pack and connect the integral wires to the positive and negative wires you marked earlier. Remember, the red wire is positive and black is negative.

The easiest connection method is to twist the wires together (first the internal wires, and then the wires running to the battery pack) and hold the join together with electrical tape. As the light will be running off a 6-volt current, this is more than adequate.

Once the wires are connected, close the ringlight and switch the battery pack on to check that your LEDs work: providing you marked your wires correctly it should.

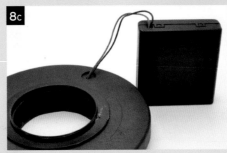

9 To finish up, you need some way of keeping the battery pack close to the light. One option is to use a belt clip from a tape measure to attach it to the camera strap (or your belt if you extend the connecting wires), but I'm using the foot from a redundant flash. You often find low-cost flashes in yard sales and online, and as you aren't going to use it, it doesn't have to be operational. All that's left is to slide the battery pack into the camera hotshoe and mount the ringlight.

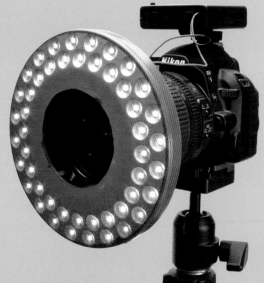

Right and Below: The LED ringlight is great for macro photography and close-up portraits, and will provide a telltale "donut" in your subject's eyes.

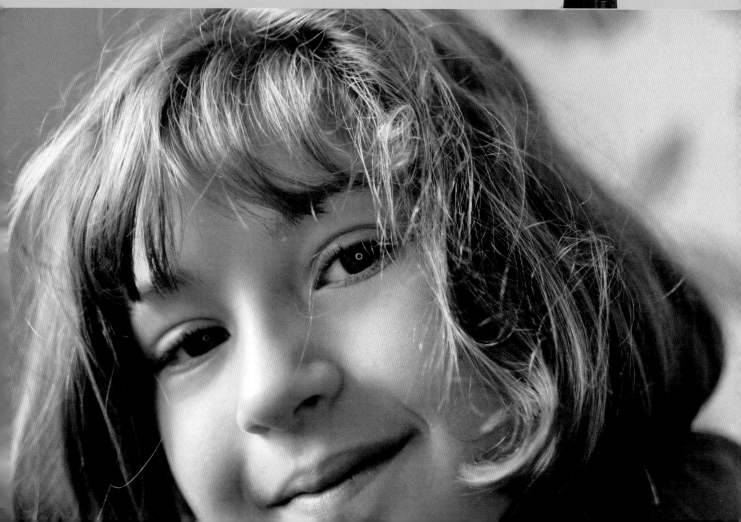

A lightbox can be a really useful bit of equipment. Not only does it make checking negatives and viewing slides really easy, but it can also be helpful while mounting and finishing print work, or even shooting, as seen in Project 14. Unfortunately, a large photographic lightbox takes up a lot of space and can be expensive. However, if both space and money are tight, why not build yourself a lightbox coffee table? For this project I used a low-cost "Lack" coffee table from Ikea. Other tables may also be suitable, but you might need to modify the construction process slightly.

1 Carefully mark out a square on the tabletop measuring 19 x 19 inches/480 x 480mm. Double check your measurements, then carefully cut along the lines using a knife and a nonslip metal ruler: it may take quite a few cuts to break through the table's surface.

Remove the honeycomb support inside the table and check your clear acrylic fits the hole you have made. You can widen the aperture with a sanding block if necessary.

2 The "Lack" table has four chipboard corner reinforcements, which will have been partially exposed when you removed the tabletop. These will form the mounting points for the clear acrylic. Chisel or cut each corner down until your 0.3 inch/8mm thick acrylic sits flush with the tabletop when inserted into the aperture. Paint the interior of the table with white gloss paint or some emulsion.

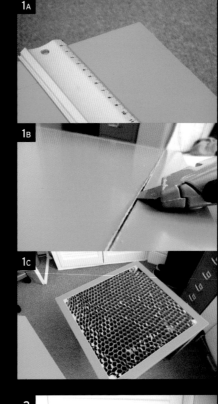

WHAT YOU NEED
- "Lack" side table (Ikea)
- 0.3-inch/8mm thick clear acrylic sheet (19 x 19 inches/480 x 480mm)
- 0.1-inch/3mm thick translucent acrylic sheet (19.5 x 19.5 inches/500 x 500mm)
- 16 foot/5 meter roll of self-adhesive white LED strip lighting (with power adapter)
- 4 screws (minimum length 1 1/4 inch/30mm)
- Drill
- Knife
- Chisel
- Sanding block

DIFFICULTY ✭ ✭

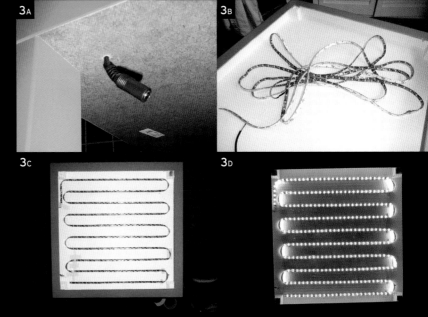

3A

3B

Drill a small hole in the underside of the table for the power adapter cable and lay out your LED strip lighting. The power adapter should have a small audio style connector that will allow you to disconnect the cable from the table when not in use.

3C

3D

Drill a hole in each corner of both of your sheets of acrylic. To mark out the position of the holes, install the sheet of clear acrylic and drill directly through it into the corner mounting points. Ensure the holes are large enough for your screws otherwise the acrylic can crack. Use these holes to mark the translucent acrylic and drill that as well.

At this point you should round off the edges and corners of the opal acrylic with a file or a sanding block.

4

The final step is to assemble the parts. Thoroughly clean both sheets of acrylic, sandwich them together, and then screw them to the table. I chose to use round-headed screws, but you could use screw caps for a smoother look.

5A

5B

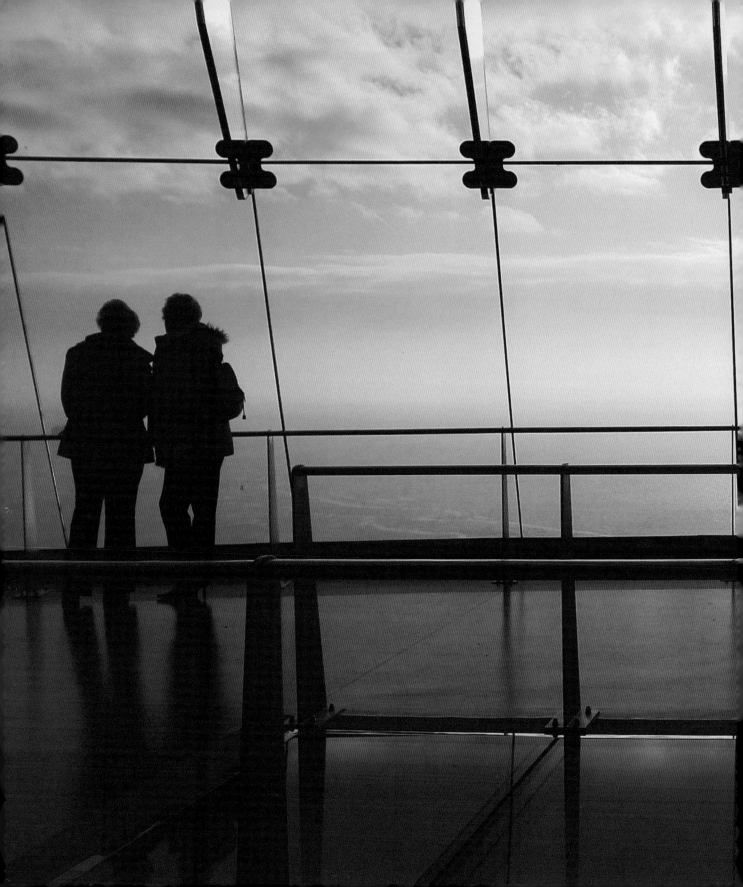

PROCESSING

The term "processing" used to apply specifically to film development and printing, but it's now more closely related to digital imaging; the processing of Raw files, for example, and the pushing of pixels. In this chapter we're not going to discriminate: we'll be covering the modern usage of the word, as well as it's analog predecessor, with a selection of projects that range from the ultra-traditional through to digital image processes that are guaranteed to transform your photographs.

39 BLACK-AND-WHITE PROCESSING

As digital photography has rocketed in popularity, many people simply don't think of shooting film any more, let alone processing it themselves. Yet images shot on black-and-white film have a very different "feel" to those recorded digitally, and surely photography is all about exploring different creative opportunities? Moreover, processing black-and-white film isn't that hard, as you'll see in this project.

Almost any black-and-white film will do, although you should avoid color films and the black-and-white emulsions designed for the C-41 color process (such as Kodak BW400CN, Ilford XP2, and Fujifilm Neopan 400CN). It might also be wise to avoid very fast or very slow films if this is your first foray—something within the range ISO 100–400 would be perfect. In this project we'll be processing a 35mm film, although the same basic principles apply to any film format.

WHICH CHEMICALS?

There are many different chemicals available for black-and-white processing, all of them excellent, and many suitable for a beginner. The chemical that "makes" the image is the developer, and this comes in two forms: liquid or powder. Liquid developers are easier to make up and better when working with smaller volumes, and Kodak HC-110, Rollei RO9 (formerly Agfa Rodinal), and Ilford Ilfosol-S are particularly recommended. Kodak's D76 and Ilford's ID11 also work well, but are only available as powders.

The other chemical you need is "fixer." Its job is to stop the film being affected by light, so the negative will not fade. Any of the so-called "rapid fixers" will be fine.

You might also hear people talk about using a stop bath (to halt the developer), but for this process plain water is all you'll need.

SOMEWHERE DARK

Before you begin, you will need somewhere that is completely dark, where you can load the film into the developing tank. A room that you can black out completely would be ideal, or you might wait until night-time, draw all the curtains, and work in the bedroom with all your equipment underneath the bedsheets—it will work!

Alternatively, you can purchase a "changing bag," which is a black, light-tight bag with elasticated holes for your arms, so you can load your film inside the bag.

LOADING THE TANK

Loading your exposed film into the developing tank must be done in total darkness (your darkroom or changing bag) as you will be taking the light-sensitive film out of its light-tight cassette. Any accidental exposure to light and you risk the film fogging.

As you're working in the dark, you will not be able to see what you are doing (obviously!), so you need to learn what everything feels like in the dark. This is actually harder than it might sound, so it's a good idea to practice loading an old roll of film in the light first, and then with your eyes shut, until you're ready to give it a go for real.

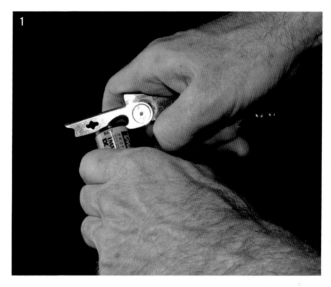

1 The first step is to open the film cassette. There are special tools to do the job, but a regular bottle opener works fine.

2 Next, retrieve the film from inside the casette and square it off with scissors. It may help to round the corners, as shown.

3 The "spiral" is what you load your film onto, and is so-called because the film forms a spiral around the central core. Most spirals are "self-loading," which means that once you get the loading started, the rest of the film will load with a twisting action.

Check your tank's instructions carefully, but in most instances you need to locate a groove that the film goes into initially. This is where your practice will pay off–if you can't find the groove, or the film doesn't go in, turn the spiral round and try again.

Once you have located the groove, push the end of your film in, and pull it gently about halfway round the spiral. Then, start the twisting motion, turning your right-hand side forward and backward, until the film is nearly loaded.

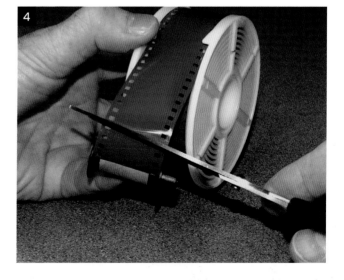

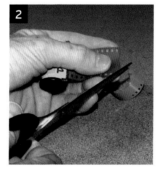

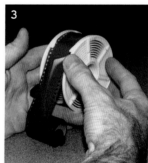

4 Remove the film from its cassette by cutting it as close to the end as possible, and make a couple more twists on the spiral to load the film fully.

Finally, put the loaded spiral on the central column of the developing tank, fit the rest of the tank together, put the top on securely, and you can return to the light once again.

PREPARING THE CHEMICALS

It is important to get all of your chemicals ready before you start. I'm using Kodak HC-110 to develop my film, and have chosen "Dilution B," which means 1 part developer to 31 parts of water (1+31), at the standard developing temperature of 20°C.

1 My first step is to get a large jug of water ready at 20°C. The instructions on your tank will tell you the minimum amount of liquid you need. My tank states that 300ml is needed to cover a 35mm film, but to keep things simple with my 1+31 mix I decided to make 320ml of developer: 10ml of the developer concentrate and 310ml of 20°C water.

2 When it's mixed, check the temperature again. If it is too hot or too cold you could stand the jug in hold or cold water and stir. A better method is to cool down or heat up a glass bottle by filling it with water, then empty the bottle and pour the developer into it. (Glass is very good at keeping its heat, and the heat in the glass will eventually pass to the developer.) You may have to repeat this process, but ±1/2°C is close enough.

3 Now you can mix the rest of your chemicals. After the developer, you will be using 300ml of plain water (again at 20°C), followed by the fixer. The fixer should be diluted according to the instructions, and should also be about 20°C, although this temperature is slightly less critical. Finally, the rest of the 20°C water will be used for washing at the end, although by this stage the temperature is not so critical—as long as the wash isn't excessively hot or cold it will be ok.

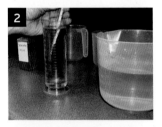

NOTES

Every film and developer combination has a specific development time, and this changes depending on the temperature of the chemistry. Therefore, it is not only important to check the recommended development time, but also to keep your temperatures consistent.

A great resource is found at www.digitaltruth.com/devchart.php, which lists thousands of times for different developer/film combinations. Here, a seven-minute development time is recommended for processing Kodak TMax 100 film (rated at ISO 100) in HC-100(B) developer.

This is a good place to start, but with experience you may want to vary your times later.

Right: A rose bush taken with Olympus OM1 and Zuiko 35mm *f*/2.8 lens, Kodak TMax 100 film and HC-110 developer.

DEVELOPING THE FILM

The process is now straightforward. You pour the first solution into the tank, wait the right length of time, pour it out, and pour the next one in—that's all there is to it! However, there are a few tips to make it work well.

The most important is agitation. If the chemicals stay in the same place they tend to get used up and become ineffective, which can lead to uneven development or, worse, insufficient fixing. The answer is to stir the chemicals, and your tank may have some method for this: most have a "twizzle stick" that can be used to gently spin the spiral inside.

A better option is to invert the tank completely (1). This should be a slow, relaxed affair (you don't need to shake the film!) and when you turn the tank upright again give it a light tap on the worksurface to dislodge any air bubbles. The whole operation should take around 5 seconds.

The amount of agitation is also important. I invert continuously for the first minute of development, and then twice every minute thereafter. Some people invert twice every 30 seconds, but whichever option you choose, you should stick with it for all your developing to maintain consistency.

Once the development time ends, pour the developer out (2). Usually, developer is only used once and then discarded.

Then, pour in the plain water that you are using as a "stop bath." The water is to dilute and wash any developer off the film, effectively "stopping" the process. You can use a chemical stop bath that will neutralize the development process chemically. In both instances, this takes about 30 seconds, with continuous agitation.

Pour out the water (or stop bath), pour in the fixer, and invert the tank a few more times. After a couple of minutes in the fix it is safe to look at your film in subdued light (3). The fixer should remove any white parts of the film and make it transparent, so if the film is not transparent it is not fixed yet. The general rule is to fix for twice the time it takes the film to go completely clear. This could be as little as 2 minutes or as much as 5 minutes or more—some films take longer than others. It is worth saving fixer as it can be used several times—sometimes there is some colored dye from the film that gets into the fixer and "tints" it, but this is not a problem.

Now wash the film in several changes of water. Four changes of water should suffice, provided you do lots of inversions. I recommend 10 inversions for the first wash, 20 for the second, 40 for the third, and then let the film stand in the fourth wash for at least 10 minutes.

Once washed, you can remove the film from the spiral and hang it up to dry, vertically, using the clothes pegs to hold it at the top and also to weight the bottom. The film is rather soft at this stage, so try to avoid handling it too much, but it is quite robust when fully dry. When dry, cut your negatives into strips and get scanning!

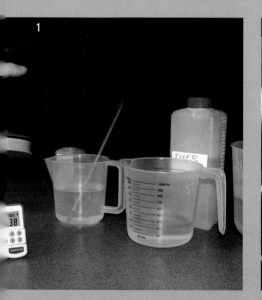

STAND DEVELOPMENT

As you've just seen in Project 39, regular black-and-white film processing requires you to agitate your developer to make sure a constant supply of fresh developer reaches the film. In this project we are going to look at the effect of slowing the development down by not agitating, and using very dilute developer. This is a technique known as "stand development," for obvious reasons, and Rodinal (now ADOX Adonal or Rollei R09) is the developer of choice for this process.

COMPENSATION

Stand development is a relaxed and easy process in which times and temperatures are not critical in the way that they are with regular processing. The main advantage of the process is that developer near the dense (highlight) areas gets used up quickly, resulting in less development in these areas, while the less dense (shadow) areas get developed more. This is called the "compensating effect" and it can help reduce contrast in a very contrasty subject. When shooting for a compensating developer you should expose for the shadows, even if this would mean "blowing" the highlights.

THE PROCESS

The only difference between stand development and regular processing is the development stage itself. With your film loaded in the processing tank as described previously, you need to make up your developer in very dilute form: 1+100, 1+150, or even 1+200. However, a minimum amount of developer is needed, so I use 5ml of developer concentrate and then simply add however much water is needed to achieve the target dilution (500ml for 1+100, 1 liter for 1+200). Some people say that you need to use at least 10ml of developer concentrate (and then dilute that), others as little as 2.5ml, but 5ml works for me.

Rather than add the developer straight away, pour water at room temperature into the developing tank to cover the film, agitate briefly, and leave this to stand for 5 minutes. This will stabilize the film temperature and reduce the chance of uneven development when you pour in your developer (also at room temperature).

Pour out the water, and pour in your dilute developer. Agitate the tank gently by inverting it for one minute, and finish by tapping the tank sharply to dislodge any bubbles that might be sticking to the film. Then simply leave the tank to stand uninterrupted. Don't move it or even nudge it!

The starting point for development is one hour with a 1+100 developer for all medium or fast films. If you find this produces negatives that are too dense, try one hour at 1+150 or 1+200 next time round. After an hour, pour out the developer and then wash and fix your film as outlined in the previous project.

NOTE

Stand development is not always ideal, and it can have a strange effect on hard edges in an image. The process can also be difficult to control—uneven development often results in streaky areas.

Agfa's Rodinal developer is not currently being made, but several companies produce alternatives, such as ADOX's Adonal.

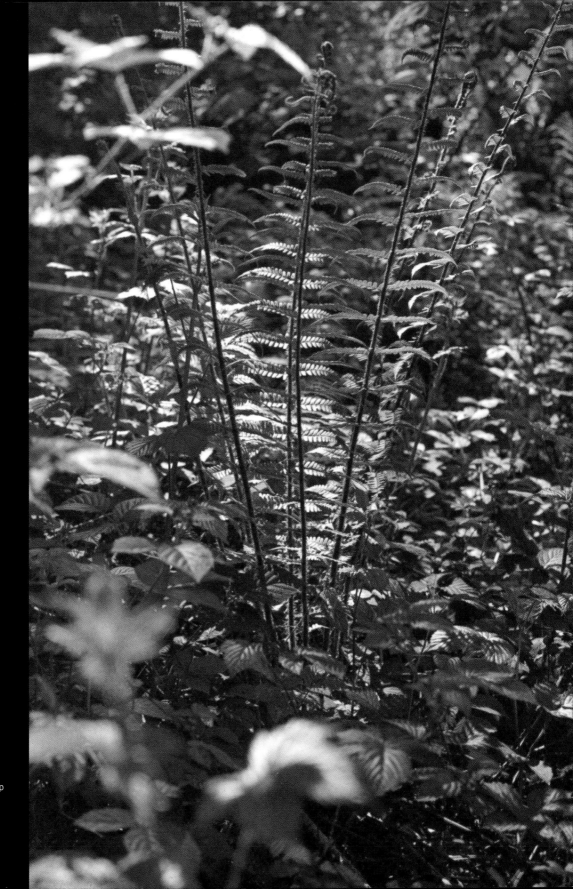

Right: Stand development can help
when the lighting is difficult, as in
this woodland scene shown here.
Its compensating effect helped to
reduce the high contrast.

Chemically, developers are "reducing agents." A number of other chemicals are also reducing agents. Two familiar ones are vitamin C (also called ascorbic acid) and coffee. When these two are combined they make a really excellent fine-grain developer. As for all developers, they must be mixed with something strongly alkaline, and we shall use another common kitchen product: washing soda.

THE FORMULA
There are numerous formulas available on the internet for coffee-based developers, but some are very unreliable or inaccurate. Below is the classic formula for the developer known as "Caffenol-C." To be sure your work is reproducible you must measure accurately and weigh your chemicals.

- 500ml water at 20°C
- 14.5g washing soda (hydrated)
- 2.7g ascorbic acid (Vitamin C) powder
- 12.2g instant coffee granules

Note that if you are using anhydrous sodium carbonate (washing soda), you should reduce the amount from 14.5g to just 5g. You should also notice that the temperature goes down about 3°C as the washing soda dissolves, so it is a good idea to start with your water at about 23°C.

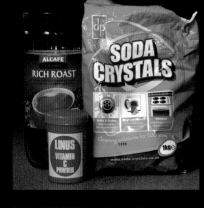

Accurate measurements are critical if you want repeatable results.

1 To make your developer, dissolve the washing soda in the water. This might take a little time, so be patient.

2 Next, add the vitamin C to the mixture and stir well.

3 Now add the coffee. This will also take a little time to dissolve, but wait until it has done so, and until any tiny bubbles and froth that sometimes form have gone. It is better to stir patiently rather than shake the mixture, as shaking can produce too much froth.

PROCESSING

1 Load your developing tank as usual.

2 Make up your chemicals. The fixer is as normal, and a plain water stop bath is preferred over a chemical stop. You should use two or three changes of water between the develop and fixing stages.

3 The rest of the process is as described in Project 39: pour in the (coffee) developer, and agitate twice a minute. It is important that you agitate very gently, as coffee easily froths up and this froth will not develop your film. One or two very gentle inversions every minute will work.

4 After development you will find it takes two or three changes of water to remove the coffee, but once removed you can fix and wash your film as usual.

Left: Juniper tree, Loughrigg Fell, Lake District, UK, 2nd June 2012. Olympus OM1 with Zuiko 35mm f2.8 lens. Agfa APX100 developed in Caffenol-C, 20 minutes.

Below: A small tarn on Loughrigg Fell, Lake District, UK. Agfa APX100 developed in Caffenol-C, 20 minutes.

Photographers have always pushed the boundaries when it comes to using (and abusing) film, from push- and pull-processing for technical or creative effect, through to cross-processing color films in the "wrong" chemistry to transform their look. This project builds on the basic black-and-white processing skills you have already seen, and explores how you can develop a color negative film designed for the C-41 process through standard black-and-white chemicals.

It goes without saying that color film is not designed to be used in this way, so the "quality" of your images will be very different. Your pictures will be less sharp and you will see an increase in grain. You may also get a two-tone color effect when you scan your negatives.

The process is very simple, and nearly as easy as regular black-and-white developing. The problem is that color film is built in many layers, and some of these do not clear to transparent when they are processed in regular black-and-white chemicals. To overcome this, one more chemical step is needed, which requires a very dilute solution of 5g Potassium Ferricyanide in 1 liter of water. This will last some time and can be used for several films.

THE PROCESS

1. Develop and fix your film as you would a regular black-and-white film (see Project 39). You may need to extend the development time slightly, but use the times detailed (right) as a starting point.

2. The fixer will not clear the color film as it would a regular black-and-white film. However, don't worry about this: fix the film for your usual amount of time (10 minutes if you don't yet have a "usual" time) and then wash and inspect your film. You should be able to see images against a dense gray background.

3. Process your film with the Potassium Ferricyanide reducing agent. This can be done in the light, but use rubber gloves and inspect the film every 30 seconds. The film should lighten and the familiar orange color that typifies a color negative should appear: to clear fully may take 5–10 minutes, although some films do not clear until they are dry (see Warning).

4. Wash your film thoroughly and hang up to dry.

DEVELOPMENT TIMES

Suggested development times to use as a starting point for your experiments. All times are for C-41 films shot at the manufacturer's recommended ISO speed:
HC-110 (1+31): 9 minutes
Rodinal (1+50): 13 minutes
D76/ID11 (1+1): 15 minutes
XTOL (1+1): 14 minutes
Ilfosol (1+9): 9 minutes

NOTES

Potassium Ferricyanide is a traditional photographer's chemical, also known as "ferri." It is available on its own, as red crystals, or as one of the main ingredients in the traditional photographic "Farmer's reducer," which is available widely.

If you scan your negatives as if they are color negatives, the scanner may detect the difference in color between the black silver and the orange mask, creating a pleasing two-tone effect.

The "straight" black-and-white image (right) may show better sharpness and more detail than the color negative processed in black-and-white chemistry (above), but the cross-processed color film has a far more unique look.

Above: Kodak Gold 200; 9 mins HC-110 (B); 8 mins 0.5% ferri.

Right: Fomapan 100; 8.5 mins Rodinal (1+50).

SUN PRINTS

One of the oldest photographic printing processes is the cyanotype, which originally used potassium ferricyanide and ferric ammonium citrate to create a mildly photosensitive solution that was coated onto paper to make it sensitive to light. Although the process was devised by Sir John Herschel in the early 1840s, it was a friend of his—Anna Atkins—who first adopted it as a means of creating photographic images. Her book, *Photographs of British Algae: Cyanotype Impressions*, was not only the first book to show the potential of the cyanotype process, but it was also the first book to be illustrated with photographic images, beating William Henry Fox Talbot's *The Pencil of Nature* by just eight months.

The cyanotype process is still used today, and as an entree into the world of "traditional" printing it has plenty going for it: there's minimal chemistry needed; the sensitized paper can be handled in subdued daylight; exposures require nothing more than daylight; and the exposed print is "developed" in plain water. However, the process can be made easier still thanks to precoated "sun print" paper, which you can buy from craft stores or online. So, if you've ever wanted to experiment with an old-school process, but didn't know where to start, or wanted to produce the distinct blue prints of a cyanotype, but didn't want to mess with chemicals, this is the project for you.

WHAT YOU NEED
· **For photograms:**
Sun print paper
Bowl or tray of water
Sheet of corrugated card

· **For digital negative printing:**
Sun print paper
Bowl or tray of water
Image-editing program
Inkjet (or laser) printer
Acetate for printer
Clip frame

DIFFICULTY ✯

TIPS

Sun print paper relies on UV light, rather than actual sunlight, so you can make exposures on a cloudy day, or even indoors. However, for the best results a strong UV light source delivers the best results.

As an alternative to the sun, you can also use a UV sun lamp (the type designed for facial tanning is ideal). As many of these have a timer, you can fine tune your exposures so they can be repeated over and over, in much the same way as using an enlarger on regular photographic printing papers.

GETTING STARTED

The simplest starting point for your sun print experiments is to create photograms, in much the same way as Atkins did in the mid 1800s. If you've done a beginner's course in traditional black-and-white printing then you'll probably know what photograms are (it's a fairly standard start point), but if not, it's pretty straightforward: you place items on the paper and then expose it to light. The result is a reversed image, so the areas your objects cover will receive little or no exposure and appear light when the paper is developed, while areas that aren't covered will come out dark (blue) when you process the paper.

1. Indoors, or in shade, take a sheet of sun print paper from the packet and pin or tape the corners to a piece of card.

2. Assemble your objects on top of the paper. Remember that the areas they cover will be unexposed, and appear light in the final image, while uncovered areas will appear dark. To start with, consider keeping things simple by sticking to strong, identifiable shapes, such as keys, leaves, or anything else with a strong outline.

3. Carefully take your paper and objects out into the sun. Place them in direct sunlight to make your exposure: the paper I'm using here recommends an exposure time of around two minutes, "until the paper turns very pale blue."

4. Once you've made your exposure, remove your object(s) and unpin/untape your sun print paper. You'll notice a "ghost" image at this stage.

5. Take your paper indoors (or back into a shaded area) and place it in a tray of water for around 60 seconds. You can agitate the tray slightly during this time if you want to. As the water washes the print, the unexposed areas will lighten, while the rest of the paper will darken.

6. After you've washed your print, remove it from the water and leave it to dry: either flat on an old newspaper, or hanging up on a washing line or similar. As the sun print paper dries, the color will intensify and the image will appear to get sharper.

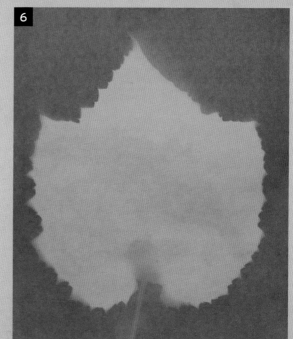

43 〉〉〉

DIGITAL NEGATIVES

Once you've mastered photograms (which, let's face it, won't take long), you'll probably be wanting to produce slightly more "photographic" images. This requires you to produce negatives at the final print size, as there's no scope to make enlargements from a negative. In the past, this would have meant using a large-format camera to make equally large prints, but thanks to digital imaging this is no longer the case: you simply need a desktop printer and some sheets of compatible acetate or clear film to print on.

1. Open your image on your computer and turn it into black and white (all image-editing programs have a "desaturate" or "black and white" option).

2. Next, you need to invert your black-and-white image so that it appears on screen as a negative: blacks become white, and whites become black. This is because the sun print process will reverse the image, so if you start with a negative you will end up with a positive print.

3. Sun print paper delivers low-contrast results—black is replaced by dark blue, and white by light blue—so it's a good idea to boost the contrast of your negative image. Again, all image-editing programs will provide you with contrast control, be it through "levels," "curves," or simply a generic "contrast" tool.

4. The next step is to resize your image so that it matches your intended print size. For example, if you want to make a 6 x 6-inch (15 x 15cm) print, you will need to size the image accordingly.

5. Print out your negative image onto acetate, or a similar printable clear film. Place a sheet of sun print paper on the backing board of a clip frame and lay the negative on top. Make sure the glass from the frame is free of dust and smears and clip the frame together.

6. You can now make your exposure, which is done in the exact same way as it is for a photogram: take your frame outside; expose it to sunlight; and then head back indoors to wash/develop the image before leaving it out to dry.

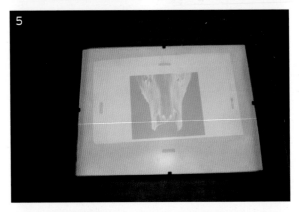

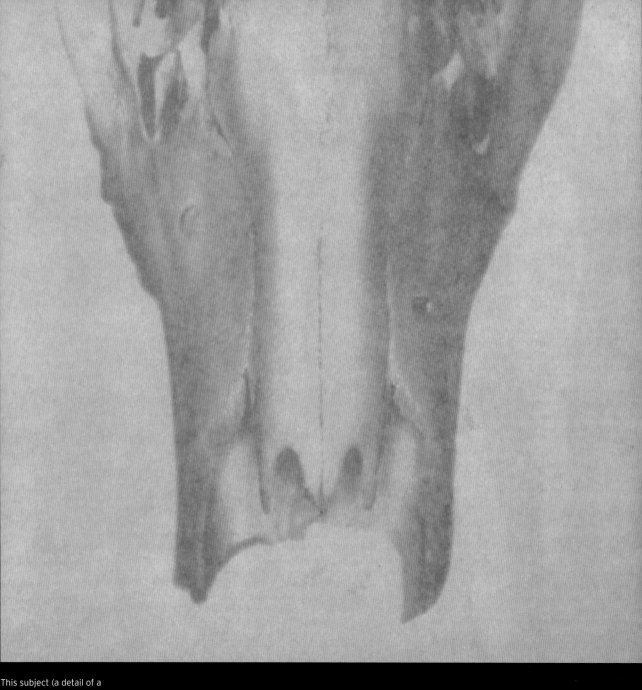

This subject (a detail of a
found sheep's skull) works
well as a sun print.

DIGITAL DAGUERREOTYPE

Photography as we have come to know it was arguably born when Frenchman, Louis Daguerre announced his daguerrotype process in 1839. However, as with most inventions (photographic or otherwise), this pioneering technique wasn't the easiest, or indeed the healthiest.

The "printed on metal" image could not be replicated easily and possessed an exceptionally delicate surface that was easily damaged through handling or chemical contamination. This is part of the reason why original daguerreotypes are relatively rare, and few of those that remain are in a "perfect" state.

With this project, we're going to use Photoshop to recreate the look of a "weathered" and aged daguerreotype, which requires two main elements: a photograph of a suitably vintage subject and an aged, metal texture to "print" it onto. I'm starting with a photograph of a pier that opened in 1870 (below left) and a stock metal texture with a distinct patina (below right).

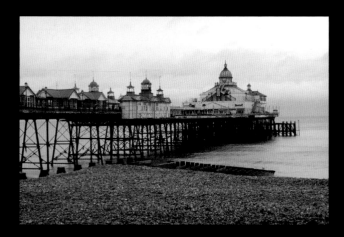

1 Daguerreotypes are invariably black and white, so the first step is to take the color out of your subject (but not the metal texture). You don't need a fancy black-and-white conversion for this, but you do want to make sure that the image remains in the RGB color space. Using the desaturate command (Image>Adjustments>Desaturate) gives a suitable "flat" grayscale conversion.

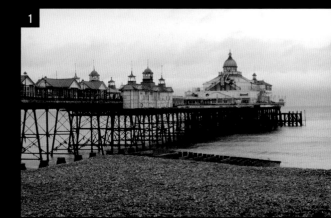

2 Next, open your texture and copy and paste it (Edit>Copy, then Edit>Paste) onto your main image. It will automatically be placed on a separate layer, but you will need to resize it (using Edit>Transform>Scale) so that it matches the size of the image.

3 To allow your image to appear through the texture, change the texture's blending mode from Normal to Multiply, and reduce the layer opacity. Here, I've set the Opacity to 35%, which gives a good balance between the image and the texture.

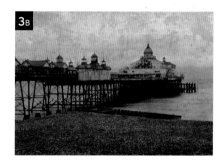
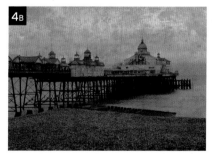

4 To fine-tune the layers, add a Curves adjustment layer (Layer> New Adjustment Layer>Curves). Generally, you will be looking to reduce the contrast of the image by lowering the top right of the curve (the highlights) and raising the lower left (the shadows).

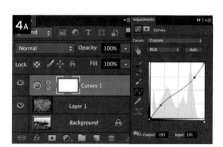

5 For added authenticity I'm going to add a vignette and slight focus fall-off at the edges of the frame to emulate the look of an old lens. Select the Elliptical Marquee tool and, while holding down the Alt key, click and drag out from the middle of the image to create a centered elliptical selection. Invert the selection (Select> Inverse) so the outer edges of the image are selected.

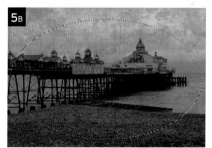

6 To make the selection fall off in a subtle fashion, switch to Quick Mask mode (press Q on the keyboard) and apply the Gaussian Blur filter (Filter>Blur>Gaussian Blur). I've used a 200-pixel blur radius to soften the mask. Press Q to return to the Standard Editing mode and, making sure the Background layer is selected, copy and paste your edge selection into a new layer (Edit>Copy/Edit>Paste).

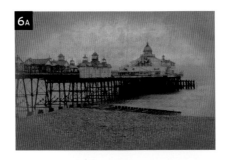

7 Edges copied to a separate layer can be worked on independently. Here, I've used Levels (Image>Adjustments>Levels) to intensify the shadows and slightly lower the midtones, and then applied Gaussian Blur with a 5-pixel radius to soften the focus slightly.

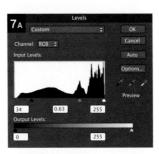

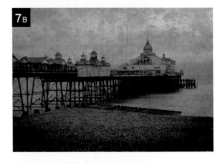

8 You can finish here if you're happy with the way your image looks, but I'm going to round off the corners to add to the vintage feel. To start with, this means increasing the size of the canvas. The actual measurements aren't important—you just need a small border (1 inch/2.5cm is enough).

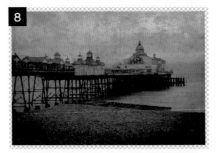

TIP

Printing your digital daguerreotype on a metallic silver inkjet paper will enhance its "printed on metal" feel. Check out your local art store for suitable papers and finishes.

9 Select the image with the Rectangular Marquee tool and smooth the selection (Select>Modify>Smooth) by 100 pixels (the maximum amount permissible). Repeat the 100-pixel smoothing to get nicely rounded corners and then Feather the selection (Select>Modify>Feather) by 1 pixel to avoid the corners appearing pixelated. Invert the selection (Select>Inverse).

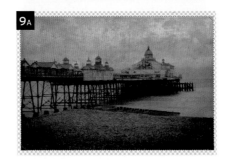

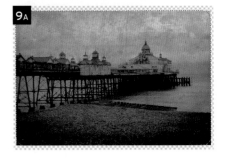

10 Create a new layer (Layer>New), and fill the edge selection with white (Edit>Fill). Drag the border layer to the top of the layers palette so that it affects all of the layers below it and your digital daguerreotype is done!

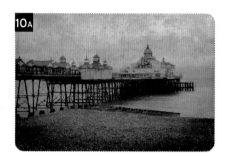

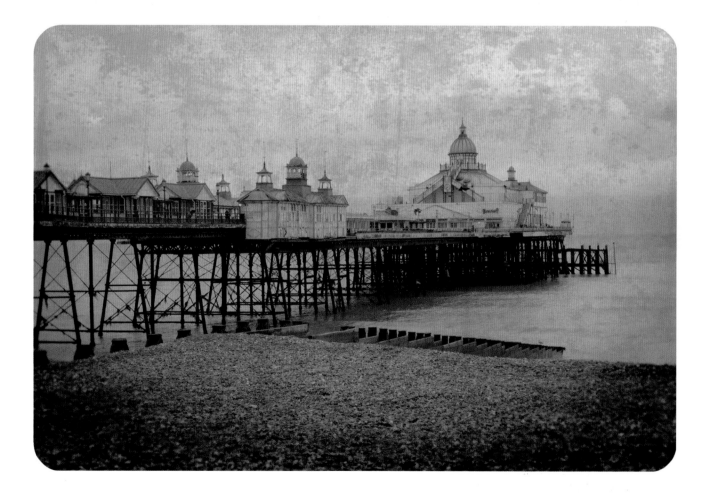

Above: The finished result of this digital daguerreotype experiment.

Traditional TTV, or "Through The Viewfinder," photography involves using two cameras: one with a waist-level viewfinder (usually an old, vintage, twin-lens-reflex style camera) and a second (usually digital) camera. The idea is that you compose your shot using the vintage camera and then use the second (digital) camera to photograph the image as it appears on the viewfinder screen. The result immediately gains a vintage feel, as you're recording all of the dust and scratches on the older camera's viewfinder screen, as well as any corner shading, focus fall-off, or irregular borders.

However, TTV isn't the most user-friendly technique. For a start you need to get a camera with a waist level viewfinder, and then you need to make what is known as a "contraption" to connect it to your digital "recording" camera. When you've done that, you're left with a rather large and unwieldy device, which isn't necessarily something you want to carry around with you. So instead, you could "cheat" and get the TTV look with your image-editing program instead.

WHAT YOU NEED
· Image-editing program with Layers, Blending modes, Blur, and brightness controls
· Digital TTV frame

DIFFICULTY ✶

1 The two main ingredients for a faux TTV image is the picture you want to transform (right) and a TTV "frame" that is resplendent with suitable defects (far right). You could shoot the frame yourself if you've got a suitable camera, or you could look online—there are plenty of free frames out there.

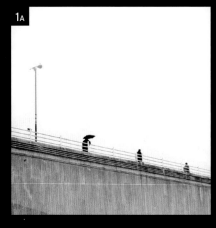

1A

1B

2 The next step is to open your image and frame in your editing program—I'm using Photoshop. Select your TTV frame and copy and paste it (Edit>Copy, then Edit>Paste) onto the image as a new layer. Dragging it onto the image also works in most editing programs.

2

3 Select the TTV frame layer and set its blending mode to Multiply: The lighter areas of the frame allow the underlying image to show through, while the black dust and frame edges remain visible. Already you can see the TTV effect taking shape.

4 If the frame is too small (or too large), resize it using Edit> Transform>Scale so that is matches the background. If necessary, use the Crop tool to trim your background image.

5 While a TTV "frame" will give you the shape, dust, and edges you're after, it can't replicate lens defects such as corner softening and vignetting, so the next step is to add these.

Start by using the Freehand Lasso tool to draw a rough selection around the center of your image. Invert the selection (Select>Inverse) and enter Quick Mask mode by pressing Q on your keyboard. Depending on your Quick Mask preferences, either the outside edges of your image or the central selection area will be masked. It doesn't matter which it is—use Filter>Blur> Gaussian Blur to blur the mask, using a high radius setting.

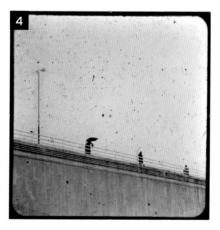

6 Press Q on your keyboard to return to Standard Selection mode. With the outer edges of your image selected, reduce the brightness using Brightness/ Contrast, Levels, or similar to add a vignette. Then, use a blur filter such as Gaussian Blur or Lens Blur to soften the edges and simulate focus fall-off.

7 The TTV picture is definitely coming together, but it's looking a bit flat compared to most TTV images—they typically have high saturation and contrast. To boost the colors, add a Hue/Saturation adjustment layer and increase the saturation. With faux TTV shots you can often increase this far more than you would for a "normal" image.

8 Finally, a Curves adjustment layer "pops" the contrast, with a gentle S-curve lightening the midtones and highlights, and darkening the shadows. The end result is a bold, TTV-style image that's full of the character of a vintage camera.

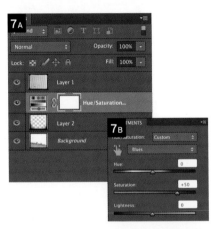

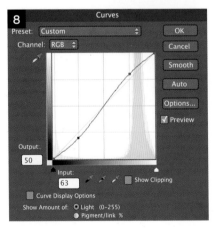

Right: Steps 1 to 8 will result in a finished image like this one.

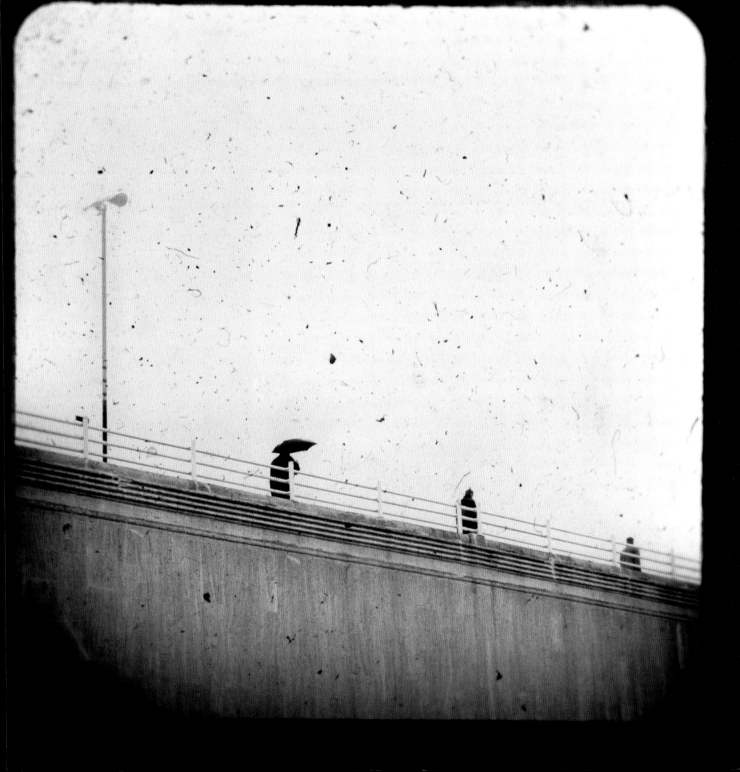

POLAROID TRANSFER

When Polaroid ceased production of its instant film production in 2008, photographers not only lost a number of unique emulsions, but also a range of creative techniques, including emulsion transfers. This process involved the photographer peeling apart their instant film almost as soon as the processing had begun, and literally "rubbing" the emulsion from the Polaroid onto a new surface—most commonly damp art paper. The result was a muted, beautifully softened image, surrounded by a gloriously "bleeding" border. It is those key ingredients of a Polaroid emulsion transfer that we will be recreating here, using Photoshop to bring more predictability to the process.

WHAT YOU NEED
- Image-editing program with Layers, Blending modes, and Blur
- Paper texture image
- Polaroid border image

DIFFICULTY ✳

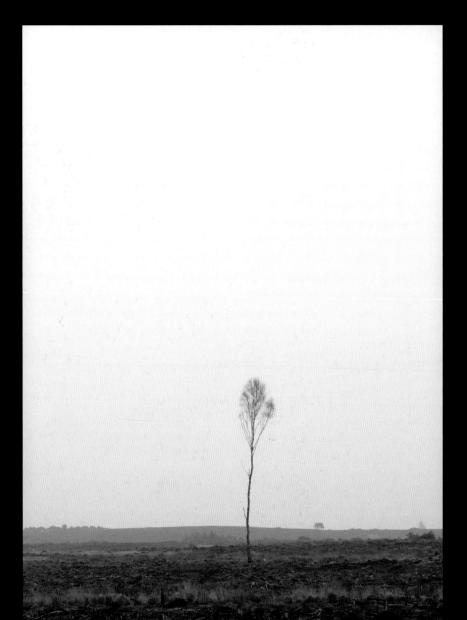

Left and Above: The components of a digital transfer: the image; the border; and the base paper texture.

1 The first step is to get all of your components into a single file, so open your paper texture and either drag or copy and paste your Polaroid border and main image onto it. Arrange the layers so the image is at the top of the stack and the border is in the middle, as illustrated. Set the blending mode for the border and image layers to Multiply.

2 If necessary, resize your border and image layers using Edit>Transform>Scale. Leave a little space between the edges of the frame and the edges of the paper texture, and size the image so that its shortest edge fits neatly inside the Polaroid border.

3 The image needs to be trimmed so that its edges match those of the sloppy Polaroid border. To do this, hide the paper layer and the image layer by clicking on the eye icon next to the thumbnail in the Layers palette. Then, with the border layer active, select the Magic Wand tool and click outside the border. In this instance I need to click twice: once on the white edge, and a second time on the transparent area outside it, while holding down the Shift key.

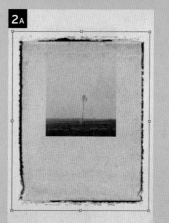

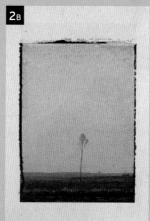

46 > > >

4 With the outside of the border selected, reactivate the paper and image layers by clicking to "re-open" their eyes in the Layers palette. Modify your selection by choosing Select>Modify>Expand and setting a 1-pixel radius, followed by Select>Modify>Feather and setting a 1-pixel radius. This will make sure that your edge is smooth. With the image layer selected choose Edit>Cut and the areas outside the Polaroid border will be removed.

5 The final stage is to blur the image slightly to emulate the loss of detail caused by the transfer process. This is achieved by applying the Gaussian Blur filter (Filter>Blur>Gaussian Blur) to the image layer, with the Radius set to 1.0 pixel—just enough to take the edge off the sharpness, but without obliterating the detail altogether.

6 With the duplicate image layer selected, apply the Gaussian Blur filter (Filter> Blur>Gaussian Blur). Check the preview button so you can use the main image window as a guide to the blur amount: you want to soften the image detail, but not obliterate it entirely. For this shot I used a Radius of 5 pixels.

7 Merge your two image layers together by selecting one of them, deactivating the paper and border layers, and then choosing Layer>Merge Visible. Re-set the blending mode of the image layer to Multiply (it will revert to Normal when you merge the layers) and use Hue/Saturation (Image> Adjustments>Hue/Saturation) to desaturate the image—setting the Saturation to around -50 is usually ideal for finishing off the transfer look.

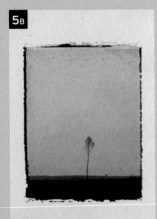

Right: The final image.

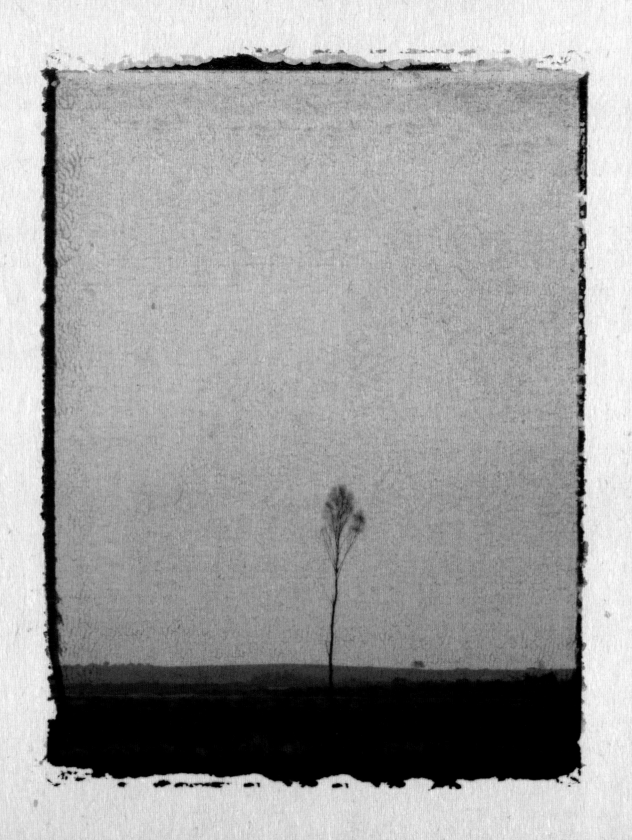

You've seen how to recreate the look of a traditional Polaroid transfer, but that isn't the only process that's associated with the company's instant film: there are also Polaroid "lifts." As the name suggests, the analog process involved physically "lifting" the Polaroid emulsion from its backing, and transferring it to another surface—most commonly a textured paper.

The key to creating a digital lift is to have an "emulsion" image that provides you with the necessary creases and textures that typify the end result. I've used a piece of clear plastic food wrap for my emulsion, which was cut into a rough rectangle and arranged on a lightbox to create the creases before being photographed with a digital camera. Any thin, transparent plastic will produce a similar result, but be sure to underexpose the image slightly to make sure that you record a full range of tones—you can lighten it later in your image-editing program.

WHAT YOU NEED

- Image-editing program with Layers, Blending modes, Liquify and Transform tools, Levels
- "Emulsion" image

DIFFICULTY ✷

TIP

A heavyweight "art" paper is the common receiving medium for an analog emulsion lift and there are two ways that you can recreate this with your digital lift. The first (and most obvious) is to print your lift image onto a textured art paper. Alternatively, you can replace the white background with a paper texture image. Before flattening the layers, copy a suitable texture into a new layer. Set the blending mode of both the emulsion layer and image layer to Multiply so that your paper texture shows through, and then adjust the layer Opacity.

Left and Above:
A successful digital lift requires two things: the image you want to use and the "emulsion" you want to apply it to.

1 The first step is to prepare your "emulsion," which means cutting it out from the background. This is where underexposing it slightly can be useful, as it will help you identify the edges. I'm using Photoshop and it required a combination of selection tools (especially the freehand lasso) to accurately select the transparent material. Once selected, copy and paste (Edit>Copy/ Edit>Paste) the emulsion into a new layer and fill (Edit>Fill) the original background layer with white.

2 Open your image file and copy it across to the emulsion, either by dragging it across or using copy/paste. Make sure the image is at the top of the layers stack and change its blending mode from Normal to Multiply so the emulsion texture shows through. The next step is to use Edit>Transform>Scale to resize the image so that it roughly covers the emulsion.

3 To make the image better fit the underlying emulsion use Photoshop's Distort tool (Edit> Transform>Distort)—the resulting distortion will add to the emulsion lift effect.

4 The next step is to emulate the way that the creases in the emulsion change the shape of the image. Make sure you're working on the image layer and open Photoshop's Liquify filter (Filter>Liquify). Set the View Options as shown, making sure that Use is set to the emulsion layer (here, Layer 1); Mode is set to Blend; and Opacity is set to 50%.

5 Set a large brush size and start to work on the image by clicking and "pushing" the image around the preview window. The aim is to follow the general shape and direction of the creases and folds in the emulsion layer. Change the brush size to make smaller or larger adjustments, and make sure that the image covers the emulsion entirely: it's a good idea to stretch the image slightly beyond the emulsion's edges. Click OK to apply the Liquify filter when you're done.

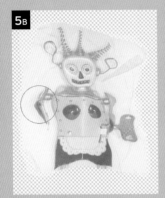

6 To match the edges of the image to the edges of the emulsion, select the emulsion layer and then the Magic Wand tool. Make sure that Sample All Layers is unchecked in the top menu and click the "empty" area that surrounds the emulsion. With the outer edges selected, Expand the selection by 1 pixel (Select>Modify>Expand) and then Feather it by 0.5 pixels (Select> Modify> Feather).

7 With your selection active, switch to the image layer and use Edit>Cut to delete the outer (selected) edges, so they are trimmed to match the emulsion beneath.

8 To finish, you can fine tune the image and emulsion layers independently to create a blend that you prefer. Here, for example, I lightened the emulsion layer using Levels and reduced the Opacity of the image layer to allow the creases to show through more.

Right: The final image.

At its very heart, photography allows you to capture a moment in time—what Henri Cartier Bresson would call "the decisive moment." However, while a single lens will enable you to record a single moment, a multi-lens camera allows you to record life as it plays out in front of you: as a series of moments, each one distinct from the next. Some of the earliest photographic pioneers used such cameras to record "action" across a sequence of frames in this way, with each picture differing slightly from the ones that came before and after it. Often, these cameras were employed for scientific (or pseudo-scientific) purposes, but in a world where digital SLRs can now capture upward of 10 frames per second (60 fps if you include HD video recording) the need to record images through multiple lenses has been all but nullified.

That doesn't mean that multi-lens cameras have become obsolete though: the first camera to bear the now-iconic Lomography name, the four-lensed Actionsampler, has been available since 1998 and similar models date back further still. More importantly, this humble plastic 35mm multi-lens camera continues to feature in the Lomography line-up, selling to a growing number of creative photographers looking to capture a little more than a single slice of life.

GET THE LOOK

Although I'll be using a bit of creative license in this project, I want to remain relatively true to the Actionsampler's traits. If you aren't familiar with the Actionsampler, it uses four lenses in a 2 x 2 configuration to record four images onto a single 35mm frame. When the shutter button is pressed, a circular shutter spins behind the quad lenses creating four 1/4-size images across a 1/2 second duration. However, as well as subject movement creating some interesting differences between the individual frames, the basic lens design and plastic construction of the camera can also lead to some very interesting results: vignetting and focus fall-off is unique to each lens, and the frames tend to overlap. There is also a general tendency for light leaks (due to the plastic camera body) and exposure discrepancies between the sequential images. These are all elements that we'll be looking to replicate.

SHOOTING THE SEQUENCE

The starting point for your Actionsampler-style image is a four-shot sequence. You can feasibly use just one shot, but it's better to shoot a genuine sequence as any movement (be it subject movement or camera movement) will add to the authenticity. The easiest way to achieve this is to switch your camera to its continuous shooting mode and fire four shot "bursts" to create individual sequences. Here I've shot a sequence of a lifeguard on a beach in the UK (right). I deliberately moved the camera very slightly while I shot so that the images don't align perfectly. I also underexposed by around 1/3 stop to retain a bit of detail in the overcast sky—I can brighten that up later if I want to.

VIGNETTE

1 Working on the first image in my sequence (using Photoshop) I'm going to create a vignette to replicate the exposure fall-off caused by a lens that doesn't quite illuminate the image area evenly. The start point for this is a freehand selection made with the Lasso tool, which roughly circles the center of the frame. This is the area I want to preserve as is.

2 Pressing the Q key enters Quick Mask mode.

3 And applying the Gaussian Blur filter (with a 150-pixel radius) softens the selection.

4 Pressing Q returns to Standard Editing Mode and choosing Select>Inverse from the top menu switches the selection from the center of the image to the outside edges and corners.

5 I can now use Levels (Image> Adjustments>Levels) to darken the edges down and create the vignette effect.

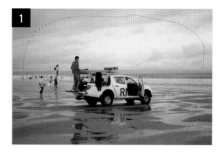

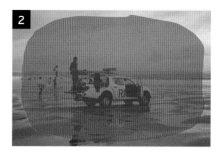

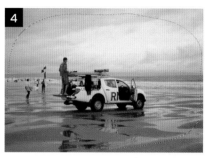

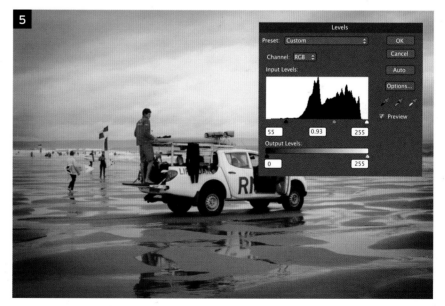

FOCUS FALL-OFF

Next on the list of effects is a fall-off in focus as the individual lenses fail to provide full edge-to-edge sharpness. The process is largely the same as creating a vignette: make a freehand selection with the Lasso tool (1); enter Quick Mask mode (2) to soften the selection with the Gaussian Blur filter (3); and invert the selection (4).

However, instead of darkening the edge layer, you want to blur it. Although Photoshop has a powerful Lens Blur filter, the less refined Gaussian Blur filter is more appropriate in this instance, with the Radius set to 5-10 pixels (5).

Repeat the steps to add an exposure and focus fall-off effect to the remaining images in your sequence (below). Don't worry about trying to match the position of your selections, or applying the same amount of corner shading or blur—no two lenses are identical, so you want to try and avoid your images appearing too closely matched.

> **TIP**
>
> Although the selection process is identical for making the selections for the vignette and focus fall-off, don't be tempted to combine the two—making individual freehand selections for each will add to the "imprecision" of the overall image.

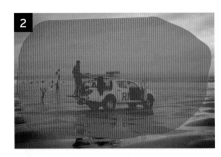

The image sequence with exposure and focus fall-off applied (below).

BRINGING IT TOGETHER

1 Once you've edited your sequence, it's time to bring your shots together. Start by creating a new file with a 3:2 ratio canvas to emulate the proportions of a standard 35mm film frame—I've opted for a 36cm x 24cm canvas size here. Add a vertical and horizontal guide to divide the image into four quarters as shown.

2 As the Actionsampler's shutter spins to reveal each lens, it exposes each image in a specific order. For our multi-lens shot we'll start at the top left and work counterclockwise, so drag (or copy/paste) shot 1 into the new master image, resizing it to fit the top left corner. Allow a small amount of overlap beyond the guide lines—this will enable you to blend the images together.

3 Next, bring shot 2 into your main image, positioning it in the bottom left section and again resizing it so it's a rough fit. Don't worry about making it a precise match to the previous shot in terms of scale and position.

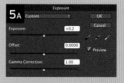
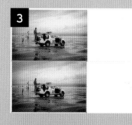
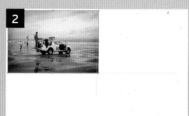

4 Repeat the previous steps to add 3 at bottom right and 4 at top right.

5 The basic structure is in place, but the images in an Actionsampler shot rarely have matching exposures. So, apply some exposure adjustments to one or more of your individual shots. You can make a shot lighter or darker, and it doesn't matter how much you adjust it by—just do what you feel looks "right" from a creative perspective. Here, I've made all of the images slightly darker using Photoshop's Exposure control, to emulate slight underexposure, with the exception of shot 2, which I've lightened to suggest a "light leak."

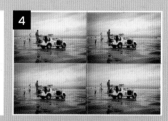
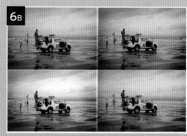

6 To create a better join between the images, change each layer's blending mode from Normal to Screen. Delete the Background layer so that the images don't simply turn white.

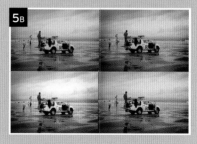

7 From here on it's a case of fine-tuning the overall look of the image using adjustment layers. Here, I've added a Curves adjustment layer to boost the overall contrast, and a Vibrance adjustment to "pop" the color a little.

8 To finish, I'm going to create a serious light leak; the sort that would bleach a film and turn the image orangey-red in a print. The basis for this is yet another freehand selection with the Lasso tool, followed by Quick Mask mode and a heavy dose of Gaussian Blur. A Channel Mixer adjustment layer then allows me to manipulate the individual red, green, and blue channels to bleach and color the selected area: experiment with the sliders until you get a result you like.

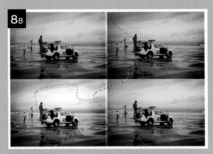

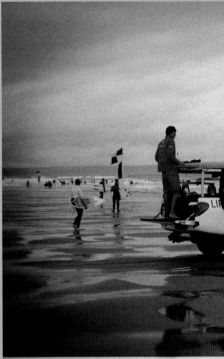
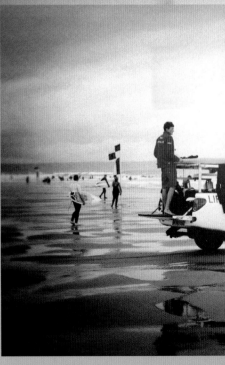

49 DIGITAL REDSCALE

Project 04 showed you how you can roll your own redscale film and start shooting images with a limited color palette, but shooting film isn't the cheapest option (even if you roll your own redscale), and the results are not predictable either. Although this unpredictability is actually part of the fun of shooting film, it's not for everyone, but just because you choose not to use film doesn't mean you can't get the redscale look with your digital images: there's every chance that your image-editing program can help you out. For this project I'm going to be using that Adobe stalwart—Photoshop.

WHAT YOU NEED
• Image-editing program with Curves, Hue/Saturation (optional)

DIFFICULTY ✶

1. Curves is a great way of changing the color in an image, and it's the basis for this project. So, the first step is to create a Curves adjustment layer (Layer>New Adjustment Layer>Curves).

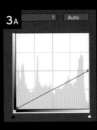
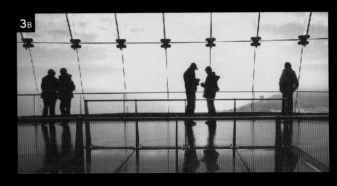

2. Use the dropdown menu at the top of the Adjustments palette to switch from the "master" RGB curve to the Red channel. Raise the left end of the curve directly upward to about the mid-way point, and then add an anchor point approximately halfway along the curve. Drag this point upward to introduce an overall red color cast.

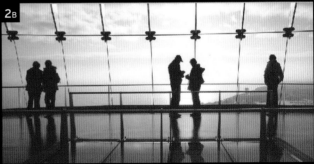

3. Switch from the Red channel to the Blue channel using the drop-down menu in the Adjustment palette. Click on the upper right end of the curve and drag this point straight down, to around the halfway point, to pump up the yellows in your shot.

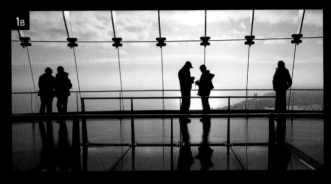

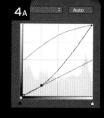

Use the dropdown menu to revert back to the "master" RGB curve (represented by a black line). This curve controls the overall "dynamic" of your image and it's up to you how you change it: I've added a single anchor point to the left of the curve and dragged it downward to intensify the image.

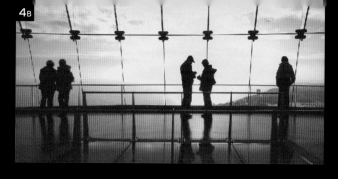

5 The redscale look is achieved almost entirely with this single Curves adjustment layer, but you can further fine-tune the color with a Hue/Saturation adjustment layer (Layer>New Adjustment Layer>Hue/Saturation). In this example I've reduced the Hue to -5 and the Saturation to -15 to create a slightly subtler result.

Below: The finished image.

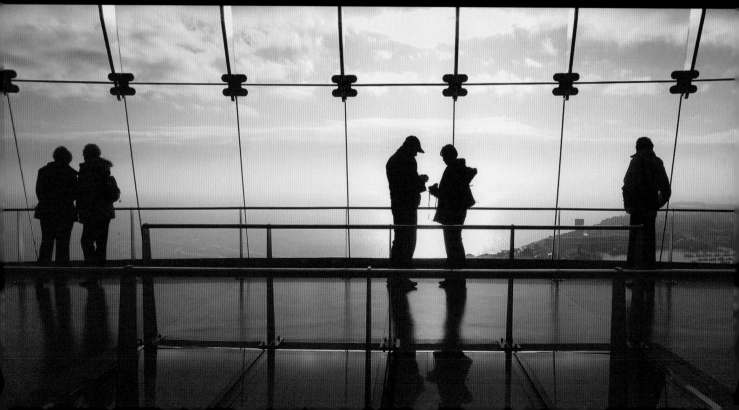

Advertising photographers are perhaps some of the most creative practitioners working in photography. I don't mean that to belittle anyone else, but the very nature of their chosen genre means that an advertising photographer has to be constantly looking at new ways of approaching their subject, in an attempt to produce fresh images that stand out in an über-competitive marketplace.

Polish photographer Andrzej Dragan is a prime example of this, and it is the broad look of what has become known as the "Dragan effect" that forms the basis of this project. Combining deep blacks,

3 A key part of the Dragan effect is deep, impenetrable blacks, so crank the Blacks slider up to the +50 mark—the image appears to be getting worse, not better, but stick with it.

4 The Fill Light slider is the next one to be tackled, and it simply needs to be increased to "lift" some of the density that we just added, but without destroying the rich blacks entirely. Somewhere in the range +75–90 is usually sufficient to do the job.

5 The basic effect is now in place, and consists of heightened color, increased sharpness, and deep blacks that still enable us to distinguish detail. All of this is achieved using just the five sliders outlined above, and you can now fine tune the result in any way you see fit. Here, I'm going to take things a step further though, starting by applying a Medium Contrast curve from the Tone Curve dialog.

6 My second optional step is to apply a vignette, which is done via the Vignettes dialog. The aim is to shade the corners a little more to help "hold" the viewer's gaze on the subject in the center of the shot. With that, the picture's complete.

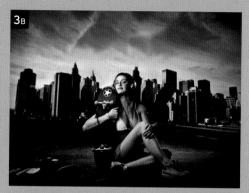

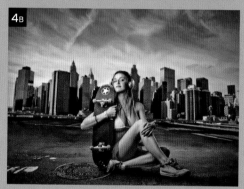

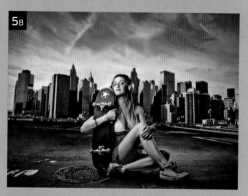

Overleaf: The final image after all the steps have been followed.

50 > > >

NOTE

For this project you can use
either Adobe Photoshop or
Adobe Lightroom if you're
processing a Raw file, but
only Lightroom is suitable if
you are processing a JPEG.
Why? Because Lightroom has
one key tool that Photoshop
does not—Clarity. While Clarity
is available in Photoshop's
Camera Raw module, it does
not feature in the program itself.
So, for this project—and the JPEG
file I'm working with—it had to
be Lightroom.

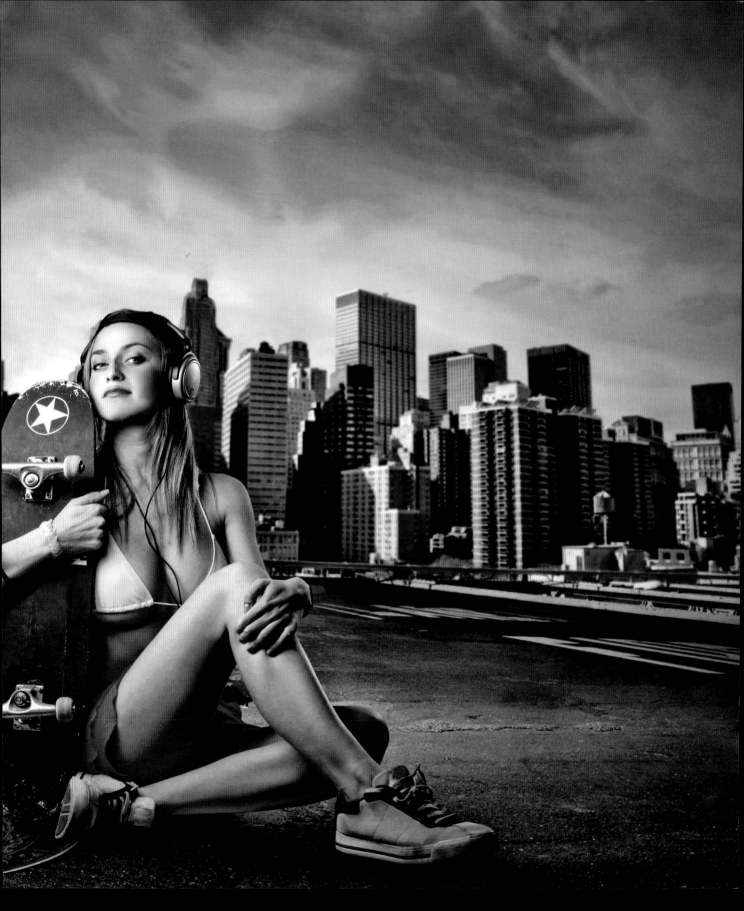

MANUAL EXPOSURE BLENDS

High dynamic range imaging, or HDRI, has become synonymous with controlling the tonal range in an image, especially with high-contrast scenes. However, it's not a perfect technology, and many images are processed to the point that they appear less like photographs and more like illustrations, with a distinctly unreal look to them. This project looks at a simple "old school" alternative: manual exposure blending.

The start point is a single Raw file, which we'll process several times to "fake" a bracketed exposure sequence, before layering it up and using masks to determine precisely how we want our image to look. Sure, it's a little more labor intensive than selecting a preset HDR option in your image-editing program, but the results can have just as much impact.

WHAT YOU NEED
• Raw converter
• Image-editing program with Layers and Masks
• Raw image

DIFFICULTY ✷ ✷ ✷

1 The first step is to "create" an exposure sequence from a single Raw image. Open the image in your Raw converter of choice and make any adjustments that you want—to the white balance, saturation, contrast, and so on—but be sure to leave the exposure untouched at this stage. When you're happy with the way your image looks, save it as a TIFF file, giving it a name that will remind you that the exposure hasn't been adjusted (I use "0.TIF" for my base exposure).

Now, without changing anything else, adjust the exposure of your Raw file to lighten or darken it. Save this adjusted version as well, using a file name that will indicate the exposure adjustment ("+1.TIF" if you've lightened it by 1 stop, for example). You can create as many alternative exposures as you want, but remember that each one should be exposed for a specific part of the image. For this Parisian landmark I settled on four exposures: the unadjusted base exposure (0); an exposure 1 stop darker (for the tower); an exposure 3/4 of a stop lighter (for the sky); and a final exposure 1 1/2 stops lighter for the foreground.

2 Open your converted images and choose File> Automate>Photomerge. In the Photomerge dialog choose Auto from the Layout options, and click Add Open Files. Make sure that the Blend Images Together option at the bottom of the window is checked before you click OK.

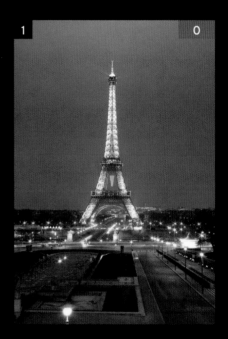

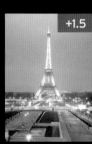

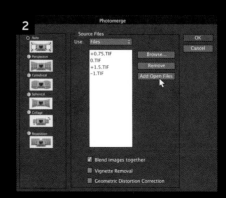

3 Photoshop will now combine and open your images as a single file, with each exposure on its own layer. All of the layers will have a layer mask: one image will have a white mask, and the others will have a black mask (indicated next to the image thumbnail in the layers palette). This means that the layer with the white mask is fully revealed, while the layers with black masks are concealed. In this example, the image that was overexposed by 1 1/2 stops is the one that is currently revealed.

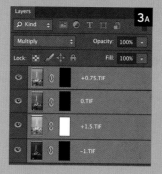

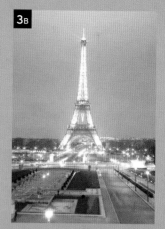

4 At this stage it's a good idea to sort the layers out. I like to work with the "0" (base) exposure as my lowest layer, with a white mask, and the rest of the layers should have a black mask. That way you can selectively add to the base exposure.

To move your layers, drag them up and down the Layers palette. The precise order doesn't matter, as long as "0" is at the bottom.

To change the color of the masks, click on the layer mask icon and choose Image>Adjustments>Invert to switch from black to white, or vice versa. Do this for each layer that needs changing, so you end up with a white mask for your base (0) layer and black masks for the rest, as shown in the accompanying illustrations.

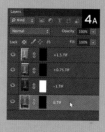
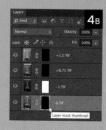
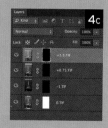

5 You're now ready to start work on the image, and this largely comes down to selectively editing the layer masks. Start by setting the foreground and background colors to black and white (by pressing D on your keyboard) and then choose the Brush tool. Select a layer to work on and click the black mask icon so you're working on the mask, rather than the image. With white as your foreground color you can now "paint" the mask to reveal an area on the layer—I've started work on the sky here.

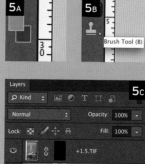
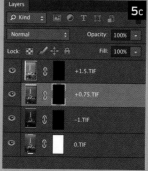

6 As you work, change the size of your brush to deal with larger or smaller areas, as well as the hardness of the brush and its opacity (a lower opacity will produce a more subtle "reveal"). If you make a mistake, switch to black as your foreground color and paint the mask back in. The basic rule is that white will reveal parts of the layer and black will conceal it; anything in between will reveal the layer to a greater or lesser degree. After a few minutes, my lighter sky is fully revealed.

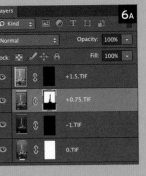

7 From here on, it's all about revealing the optimum bits of each layer, using a mix of brushes and opacity settings to reveal the detail you want included in the image. Using large, soft-edged brushes at a low opacity, and making several passes with the brush helps to avoid obvious "edges" appearing in your image, producing a better result, even if it takes longer.

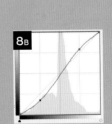

8 As well as manipulating the masks, you can also adjust the layers using Levels, Curves, Opacity, and so on. In this image I reduced the Opacity of the darkest layer to 75% so its effect wasn't quite as strong, and then applied a contrast-boosting S-curve to the sky (+0.75) layer to enhance its color. A Curves adjustment layer was also added to boost the overall contrast and saturation.

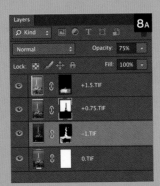

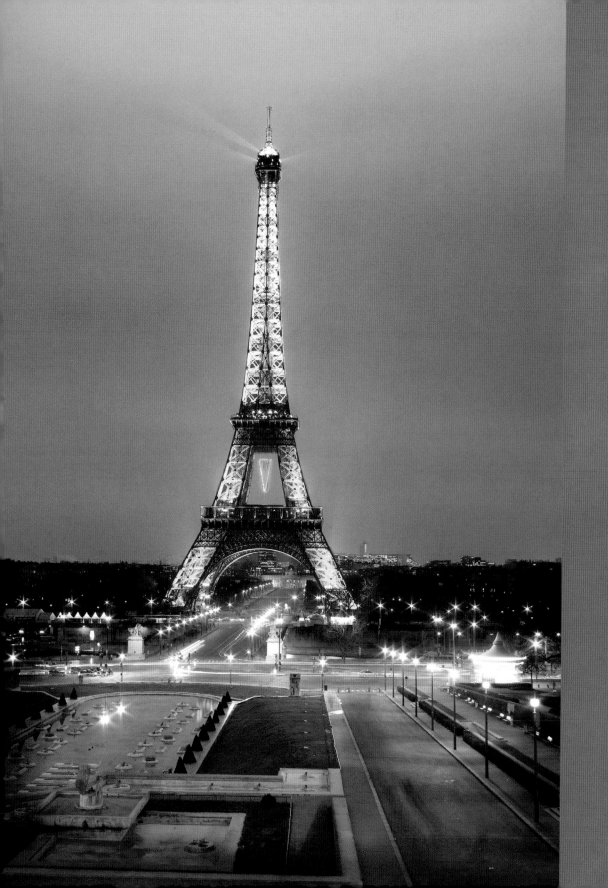

Until now we've looked at a wide variety of ways in which you can create images, whether it's on film or digitally, and you've seen myriad accessories that will help you achieve your creative goals. This last project is simply a fun way that you can transform some of those images from your computer screen (or neg files) into something tangible: a photo cube. You can choose to make one or many; make them big or small; or maybe even think about creating alternative shapes—the choice is yours!

WHAT YOU NEED
· Image-editing program with Layers
· Cube template
· 6 digital images
· Printer
· Scissors
· Glue

DIFFICULTY ☆

1 The first step is to find yourself a cube template. There are many templates online that are free to use (just search "cube template"), or you can draw your own if you've got an illustration program on your computer. Once you've done that, open the template in your image-editing software.

2 Open the first image that you want to add to your cube. If it isn't square already, you'll need to crop it. In Photoshop, use the Crop tool and hold down the Shift key while you click and drag the crop area: this will constrain the crop to a square. Press Enter to implement this.

3 Drag your picture onto your cube template (or copy and paste it) and position it over one of the cube's squares. Use Edit> Transform>Scale to fit it precisely. Again, hold down the Shift key while you rescale the image so that it holds its proportions.

4 Repeat steps 2 and 3 to add additional images to your cube, cropping and scaling them to fit the six faces. While each image is on its own layer you can edit it individually, or you can add an adjustment layer to make changes to all of the images together—to convert them to black and white, for example, or add an overall color tone, as I've done here.

5 When you're done, flatten the layers down (Layer>Flatten Image) and print your cube template. Cut it out and carefully score along each of the lines so they will fold neatly. Then, glue the tabs, stick it together, and you're done—one custom photo cube with a selection of your favorite shots. They also make great gifts!

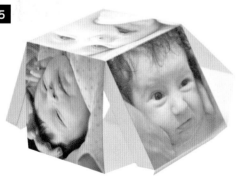

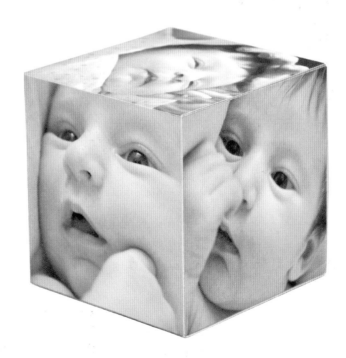

REFERENCE

PICTURE CREDITS

Unless otherwise stated, text and images by Chris Gatcum *(www.cgphoto.co.uk)*

CHAPTER 1 OPENER
Daniel Lih
www.flickr.com/photos/daniellih

01 EXPOSE TO THE RIGHT
Text & images: David Taylor
www.davidtaylorphotography.co.uk

02 STUNNING SILHOUETTES
Text: Chris Gatcum

 Sgt. Mark Fayloga
United States Marine Corp.

 Stockbyte/Photos.com
www.photos.com

 Chris Gatcum
www.cgphoto.co.uk

03 SPROCKET SHOTS
Text: Chris Gatcum

 Jeeheon Cho
www.jeeheon.com
www.dividedskies.wordpress.com

 Allison Pasciuto
www.flickr.com/apasciuto

04 REDSCALE
Text: Chris Gatcum

 Anabella Dichoso
www.flickr.com/urban_faeru
www.trinketsoflove.tumblr.com

 Oscar Paradela
www.oscarparadela.com

05 INFRARED
Text & images: Luis Argerich
www.luisargerich.com

06 LEVITATION
Text & images: Rosie Kernohan
www.rosiekernohanphotography.com
www.flickr.com/outoftherose

07 BRENIZER METHOD
Text: David Taylor

 Brendon Burton
www.flickr.com/burtoo

 David Taylor
www.davidtaylorphotography.co.uk

08 FREELENSING
Text & images: Daniel Lih
www.flickr.com/photos/daniellih

09 SINGLE CAMERA STEREO
Text & images: Sascha Becher
www.stereotron.com
www.flickr.com/stereotron

10 MOONRISE
Text & images: David Taylor
www.davidtaylorphotography.co.uk

11 STAR STACKS
Text & images: David Taylor
www.davidtaylorphotography.co.uk

14 LIGHTBOX SHOTS
Text & images: Chris Gatcum

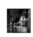 **iStockphoto.com/**
Lior Filshteiner
www.istockphoto.com

CHAPTER 2 OPENER
Freddie Peirce
www.neverstop-photography.co.uk
www.flickr.com/fineshade

18 SUPER ND FILTER
Text & images: Freddie Peirce
www.neverstop-photography.co.uk
www.flickr.com/fineshade

CHAPTER 3 OPENER
Denis Tangney Jr/iStockphoto.com
www.istockphoto.com

24 WIDE GRIP
Text & step-by-step
images: Chris Gatcum

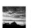 **KingWu/Photos.com**
www.photos.com

25 LOW-ANGLE GRIP
Text & step-by-step
images: Chris Gatcum

 George Doyle/Photos.com
www.photos.com

26 SHOULDER RIG
Text & images: Tobias Deml
www.tobiasdeml.com

27 TABLE DOLLY
Text & images: Scott Eggleston/
The Frugal Filmmaker
www.thefrugalfilmmaker.com
www.youtube.com/thefrugalfilmmaker

28 BIKE MOUNT
Concept & text: Matthew Mosher
www.matthewmosher.us
Step-by-step images: Chris Gatcum

 Denis Tangney Jr/
iStockphoto.com
www.istockphoto.com

29 MICROPHONE SHOCK MOUNT
Text & images: Scott Eggleston/
The Frugal Filmmaker
www.thefrugalfilmmaker.com
www.youtube.com/thefrugalfilmmaker

AwardSound/photos.com
www.photos.com

30 MICROPHONE BOOM ADAPTER
Text & images: Scott Eggleston/
The Frugal Filmmaker
www.thefrugalfilmmaker.com
www.youtube.com/thefrugalfilmmaker

31 THE MILK EFFECT
Text & images: Tobias Deml
www.tobiasdeml.com

INDEX

ACKNOWLEDGMENTS

Without hesitation I need to thank all the guys (and gals) who contributed to this book in one way or another, so a big "thank you" to (deep breath) Alex Fagundes, Allison Pasciuto, Anabella Dichoso, Brendon Burton, Daniel Lih, David Taylor, Freddie Peirce, Jack Watney, Jeeheon Cho, Luis Argerich, Matthew Mosher, Oscar Paradela, Richard Kaye, Rosie Kernohan, Sascha Becher, Scott Eggleston, and Tobias Deml.

Thanks also to Adam and Roly at Ilex for giving me the opportunity to follow up *Creative Digital Photography: 52 Weekend Projects*; Natalia for editing my words and screaming silently when I stretched my deadlines (again); and Ma and Pa for the new view from my desk.

And always last (but never least), N, T, and GM for keeping me sane(ish) throughout it all.